101 WAYS TO
DRAW

A Field Guide to Drawing Mediums and Techniques

David Webb

DAVID & CHARLES

www.davidandcharles.com

INTRODUCTION

Drawing can be defined as the picturing of objects on a surface, and as such anyone can draw. This spontaneous childhood activity is often dropped as we grow up and become more critical of our efforts – the gulf between what we can see and what we can draw seems too great and we give up in frustration. Drawing, however, can be learned and, as with most things, practise improves our skill even if it does not always achieve perfection.

Start by setting aside a short time each day for drawing. Always carry a small sketchbook and pencil with you and fill in the odd five or ten minutes by drawing anything you can see around you. Look at the scene or the object and draw what you see, rather than what you expect the subject to look like. Use exercises, such as drawing negative spaces, to make you look really hard at creating what is in front of you. As you improve, try to build up a collection of references for future compositions; aim to capture a movement, the essentials of an object, an interesting juxtaposition of elements in a scene. Your sketchbooks will soon become an invaluable resource.

Once you get hooked on drawing you will want to experiment with the many different media available. The physical differences between using crumbly charcoal, powdery pastels and greasy oil sticks will dictate what you draw and how you apply them to the support. For fine detail, pencils of all kinds, pens and ball-points cannot be bettered. Working large with bold sweeps and strong lines needs drawing tools such as charcoal, felt-tip pens or pastels. Some drawing media can be erased easily, others stain the paper; some demand you work quickly and confidently, while others are capable of delicate, precise lines where just a suggestion is enough to create an interesting image. What you draw on is as important as choosing what to draw with and matching the medium to the support can be the key to a successful picture.

Drawing accurately is not the only skill. Creating an impression or a feeling is equally important. When drawing from life try to work on the picture as a whole rather than concentrating on a small area. Use a variety of lines – fine and light or dark and heavy, continuous or sketchy – to keep the drawing interesting and lively. Introducing contour lines, building up the shading or adding a wash will make the composition three dimensional.

It is never too late to start drawing, the materials are as cheap or as expensive as you choose and the subject matter is all around you. Now pick up a pencil and begin. Keep your old sketchbooks and first drawings and after a few months look back to see how much you have improved.

HOW TO USE THIS BOOK

This is not a step-by-step drawing book or a book that tells you how or what to draw. Nor does it spend time exploring the whys and wherefores of each medium. Instead it is a visual directory of drawing techniques providing you with everything you need to explore and experiment with different techniques and mediums. Use it as a handy reference for when you want to know how to use a particular tool, or as a catalogue of inspiration when seeking new ideas to try.

As the techniques progress, you'll explore the creative possibilities beyond one medium, and be encouraged to look at your work and style in a new light. Use this section as an aid to expression and skill development and to look at the myriad possibilities of mixed media, which have all been selected because of their compatibility.

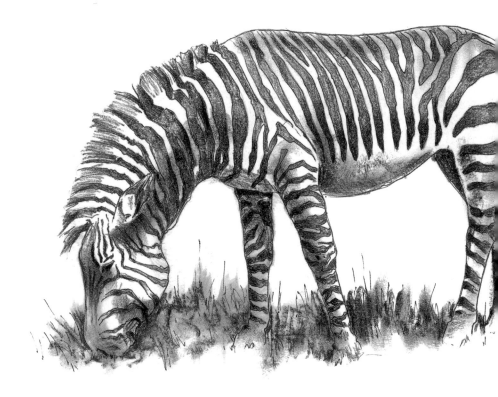

1 LINE AND TONE

Choose a smooth drawing paper and HB, 2B and 4B pencils to experiment with different techniques.

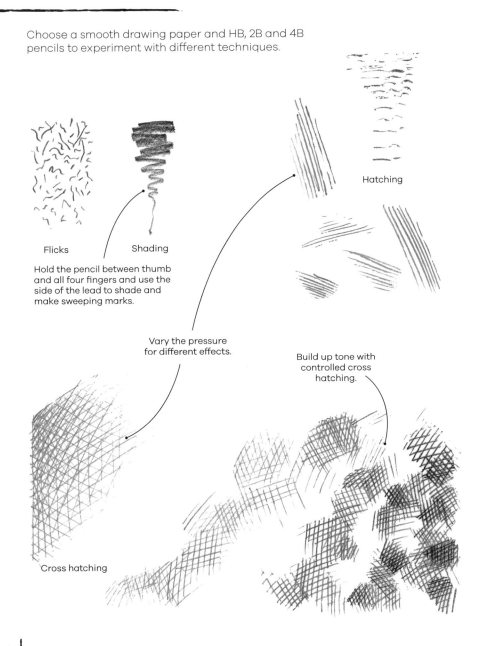

Flicks

Shading

Hold the pencil between thumb and all four fingers and use the side of the lead to shade and make sweeping marks.

Hatching

Vary the pressure for different effects.

Build up tone with controlled cross hatching.

Cross hatching

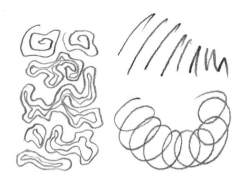

Scribbles

Hold an HB pencil vertically or at a slight angle between thumb and forefinger to create crisp detailed drawings.

HB

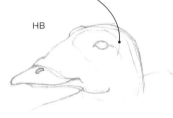

Build up texture and volume using scribbles, tiny flicks, stippling, hatching and cross hatching.

2H

2B

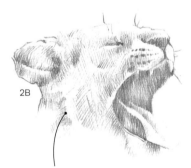

B

The softer graphite leads of 2B or 4B pencils can be used to demonstrate expression.

2 SHADING AND BLENDING

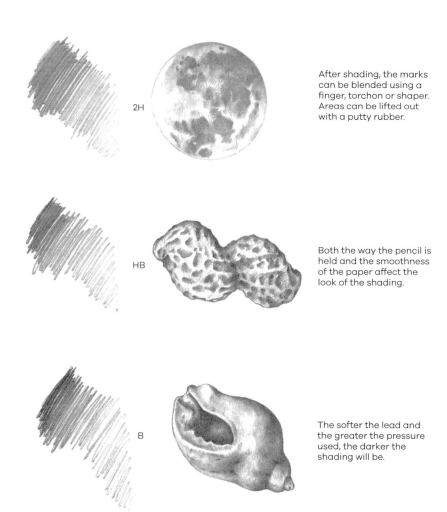

2H

After shading, the marks can be blended using a finger, torchon or shaper. Areas can be lifted out with a putty rubber.

HB

Both the way the pencil is held and the smoothness of the paper affect the look of the shading.

B

The softer the lead and the greater the pressure used, the darker the shading will be.

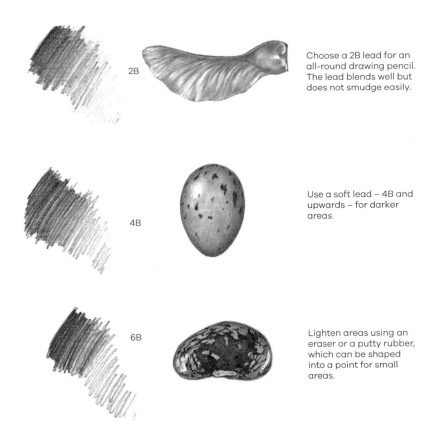

2B

Choose a 2B lead for an all-round drawing pencil. The lead blends well but does not smudge easily.

4B

Use a soft lead – 4B and upwards – for darker areas.

6B

Lighten areas using an eraser or a putty rubber, which can be shaped into a point for small areas.

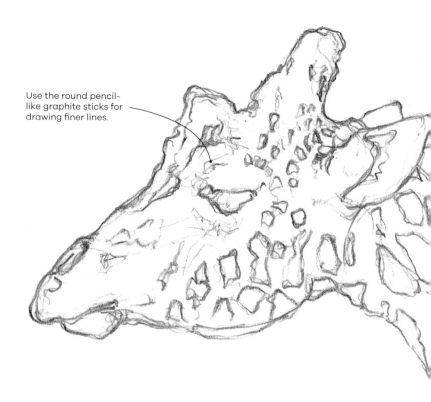

Use the round pencil-like graphite sticks for drawing finer lines.

GRAPHITE STICKS

3 LINE AND TONE

Graphite sticks are soft, ranging from HB to 9B, and smudge easily, so whenever possible work from left to right (or right to left if you are left-handed) and try not to rest your hand on the support.

As you cannot produce as detailed a drawing with graphite sticks as you can with traditional graphite pencils, they encourage a looser drawing style and are ideal for large-scale work.

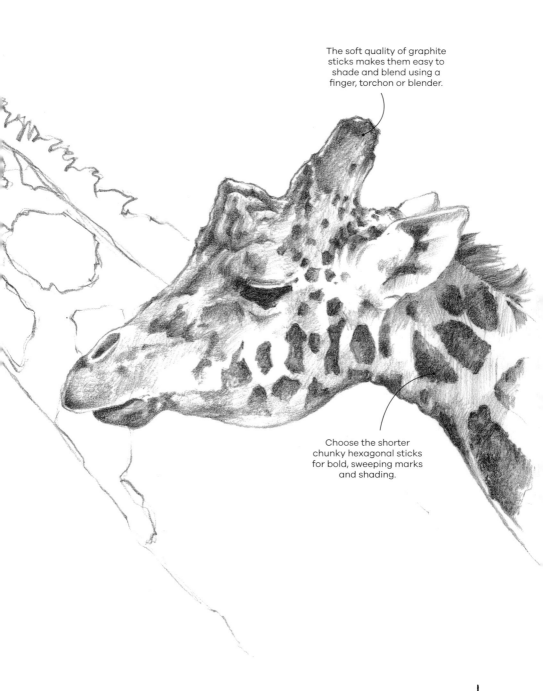

The soft quality of graphite sticks makes them easy to shade and blend using a finger, torchon or blender.

Choose the shorter chunky hexagonal sticks for bold, sweeping marks and shading.

GRAPHITE STICKS

4 TEXTURES

Three different types of paper were used here, with
four different graphite leads, to show how the paper
surface can affect the texture of the marks.

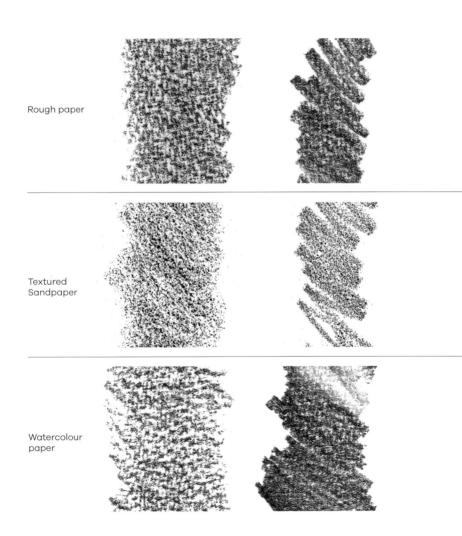

Rough paper

Textured
Sandpaper

Watercolour
paper

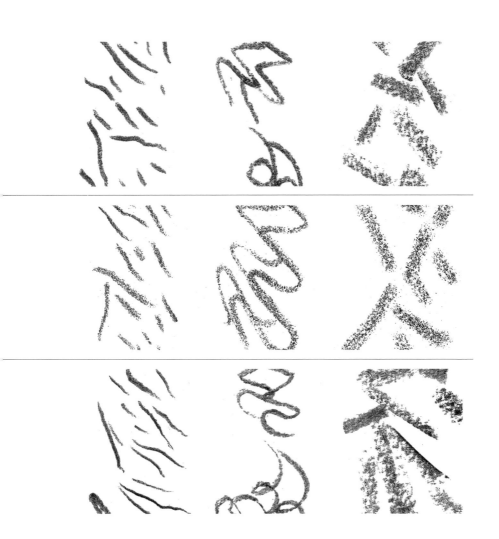

5 APPLYING TONE

Transfer the powder by simply tipping a little on to the surface and then dip a finger into it.

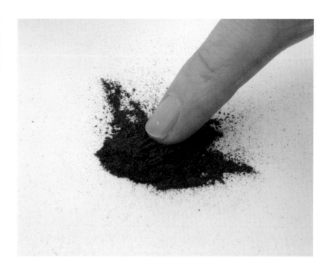

To create areas of shading, simply rub the powder directly on to the support.

Alternatively, use a stiff bristled brush or a torchon, as well as your finger to create different effects with the density of the powder.

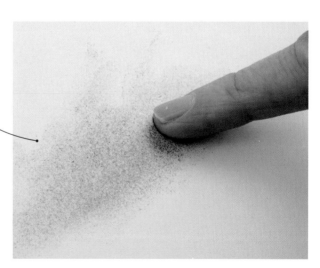

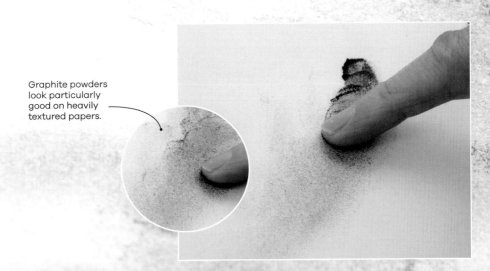

Graphite powders look particularly good on heavily textured papers.

They are useful for shading large areas of a drawing.

CREATING TEXTURES, 6 ERASING AND FIXING

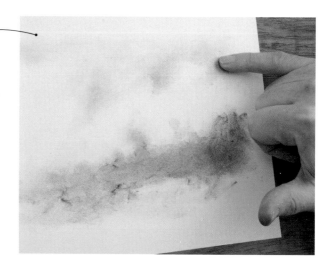

Interesting cloud effects are possible using a small amount of graphite powder.

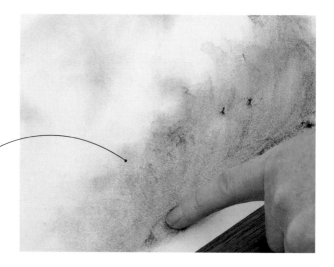

Build up the darker areas slowly by gradually adding more powder.

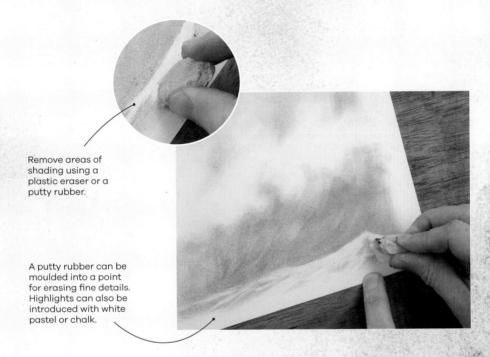

Remove areas of
shading using a
plastic eraser or a
putty rubber.

A putty rubber can be
moulded into a point
for erasing fine details.
Highlights can also be
introduced with white
pastel or chalk.

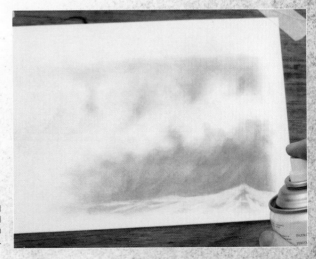

The finished
drawing will need
to be fixed using a
spray fixative.

7 LINE AND TONE

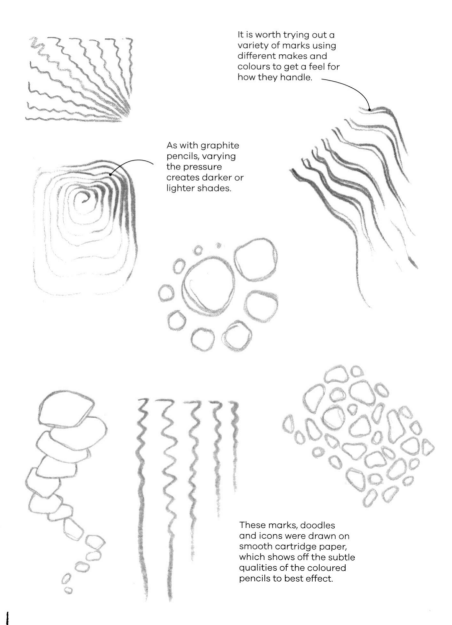

It is worth trying out a variety of marks using different makes and colours to get a feel for how they handle.

As with graphite pencils, varying the pressure creates darker or lighter shades.

These marks, doodles and icons were drawn on smooth cartridge paper, which shows off the subtle qualities of the coloured pencils to best effect.

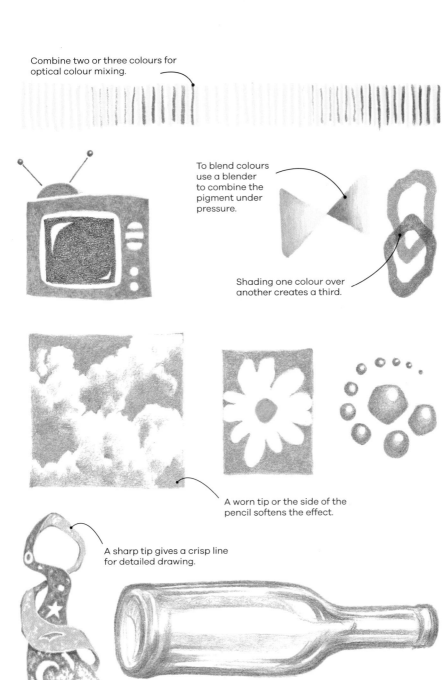

Combine two or three colours for optical colour mixing.

To blend colours use a blender to combine the pigment under pressure.

Shading one colour over another creates a third.

A worn tip or the side of the pencil softens the effect.

A sharp tip gives a crisp line for detailed drawing.

8 BUILDING UP SHAPE

Coloured pencils do not smudge easily and are not easy to erase. They cannot be blended but building up layers of colour results in optical colour mixing.

Start by outlining and defining the shape with a pale colour.

Build up the shaping with dots of colour placed close together in the darker areas.

Less closely spaced dots of colour are used in the area of the highlights.

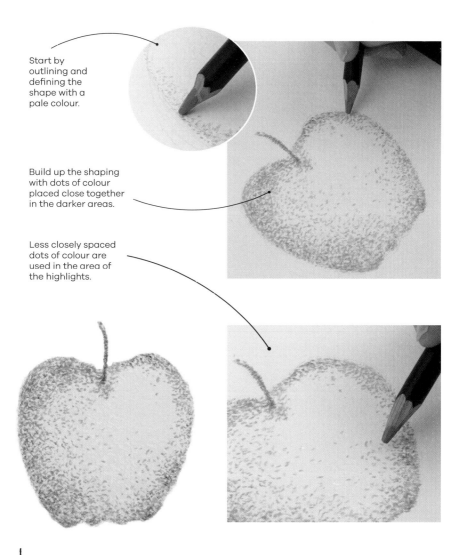

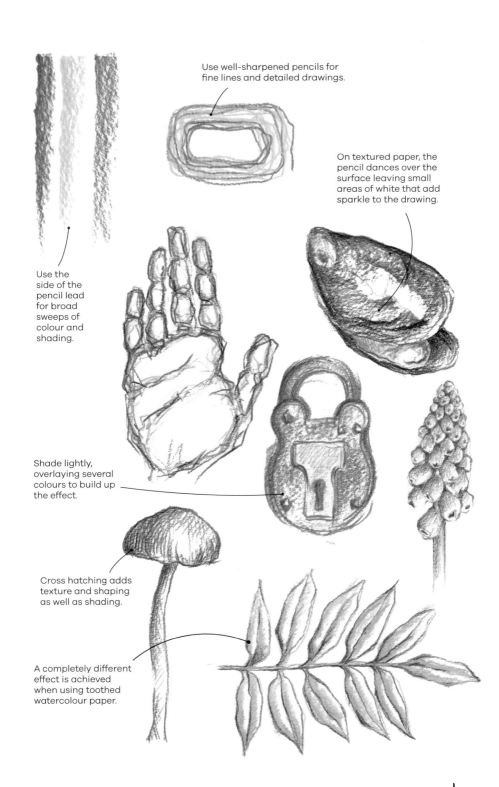

Use well-sharpened pencils for fine lines and detailed drawings.

On textured paper, the pencil dances over the surface leaving small areas of white that add sparkle to the drawing.

Use the side of the pencil lead for broad sweeps of colour and shading.

Shade lightly, overlaying several colours to build up the effect.

Cross hatching adds texture and shaping as well as shading.

A completely different effect is achieved when using toothed watercolour paper.

19

9 BURNISHING

Burnishing is layers of coloured pencil overlaid with strong pressure so a smooth surface results. This image shows the contrast between the loose style of drawing with simple shading used for the motorbike, and the burnished area of the shiny fuel tank.

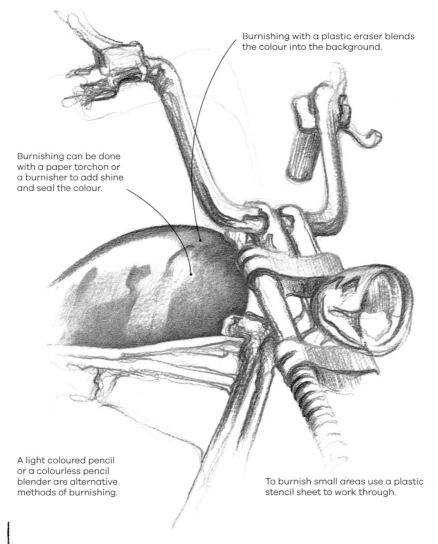

Burnishing with a plastic eraser blends the colour into the background.

Burnishing can be done with a paper torchon or a burnisher to add shine and seal the colour.

A light coloured pencil or a colourless pencil blender are alternative methods of burnishing.

To burnish small areas use a plastic stencil sheet to work through.

LIFTING AND SGRAFFITO 10

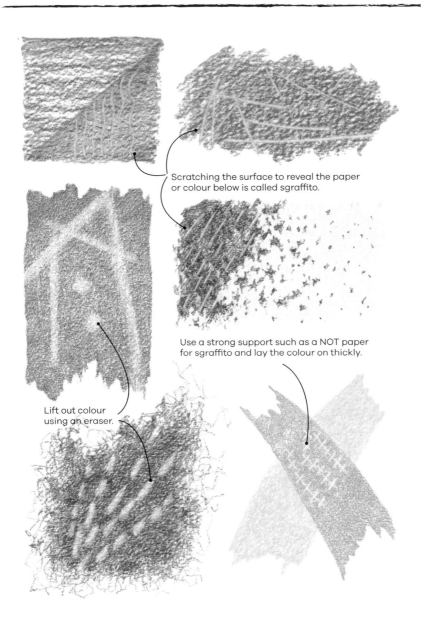

Scratching the surface to reveal the paper or colour below is called sgraffito.

Use a strong support such as a NOT paper for sgraffito and lay the colour on thickly.

Lift out colour using an eraser.

11 DRY ON DRY PAPER

Use these pencils like ordinary coloured pencils or add water in a variety of ways to achieve very different effects.

Start drawing with a dry water-soluble pencil on a dry support.

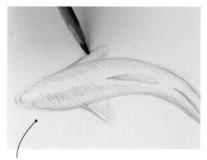

Dip a second pencil in water to strengthen the depth of colour and get a slightly smudged effect. Take care not to get the wood too wet or it will warp.

WATER-SOLUBLE COLOURED PENCILS

12 DRY ON WET PAPER

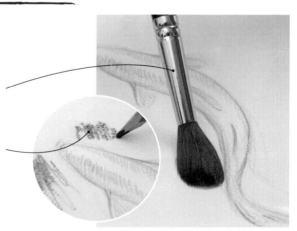

You can then wet the paper round the drawing using a large mop brush.

Drawing into the wet areas dissolves the pigment.

DRY THEN ADDING WET BRUSH 13

The colour can be spread using a soft wet brush. Depending on the effect required, the pencil lines can be left visible or be given the appearance of a wash.

WET POINT ON DRY PAPER 14

After the paper has dried, detail can be added. By dipping the pencil in water the depth of colour can be strengthened.

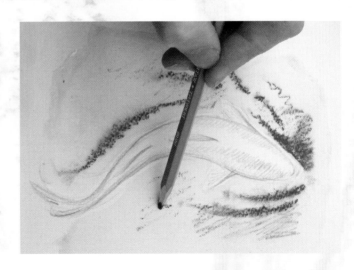

15 WET BRUSH

In this drawing the colours were softened and blended using a wet brush after the drawing was complete. The original pencil lines are still visible.

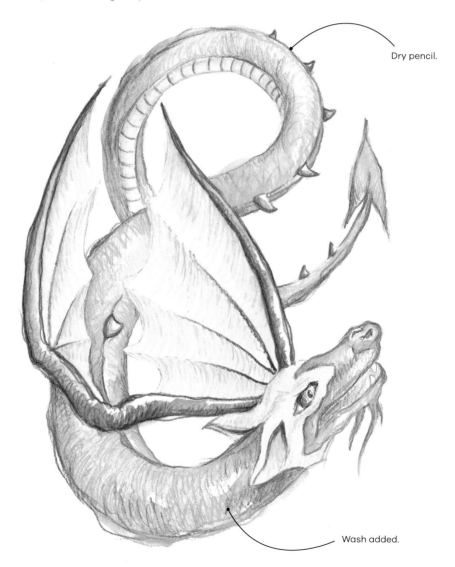

Dry pencil.

Wash added.

WET PENCIL 16

The stronger, blended colours here were achieved by dipping the water-soluble coloured pencils in water. The pencil lines are no longer visible. Take care not to get the pencil wood too wet or it will warp.

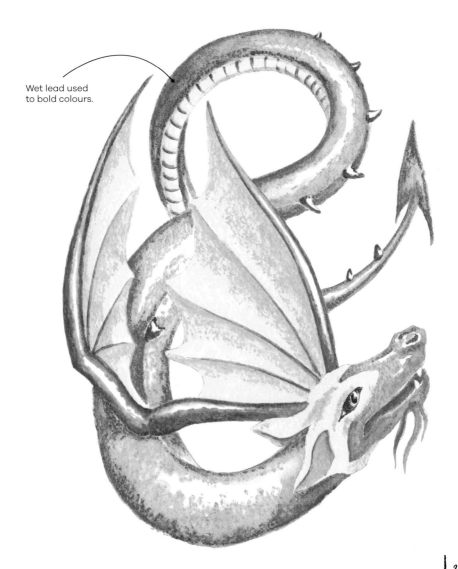

Wet lead used to bold colours.

17 BLENDING WITH A BRUSH

Lay down the pale colours first followed by the darker ones.

Blend them together with a wet brush.

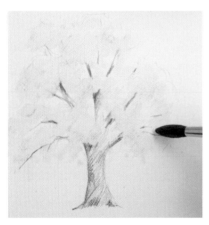

Experiment with how much colour pigment to apply and how much water to use. Different brushes will also affect the results.

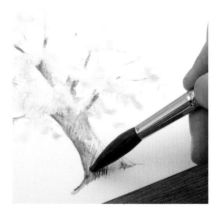

Allow the painted areas to dry completely before moving on to others, to prevent them bleeding into each other.

WATER-SOLUBLE COLOURED PENCILS

APPLYING BY BRUSH 18

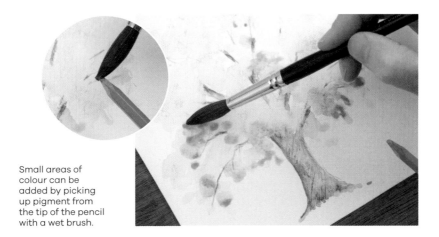

Small areas of
colour can be
added by picking
up pigment from
the tip of the pencil
with a wet brush.

19 OVERLAYING COLOURS

Delicate effects can be created using the water-soluble properties with restraint.

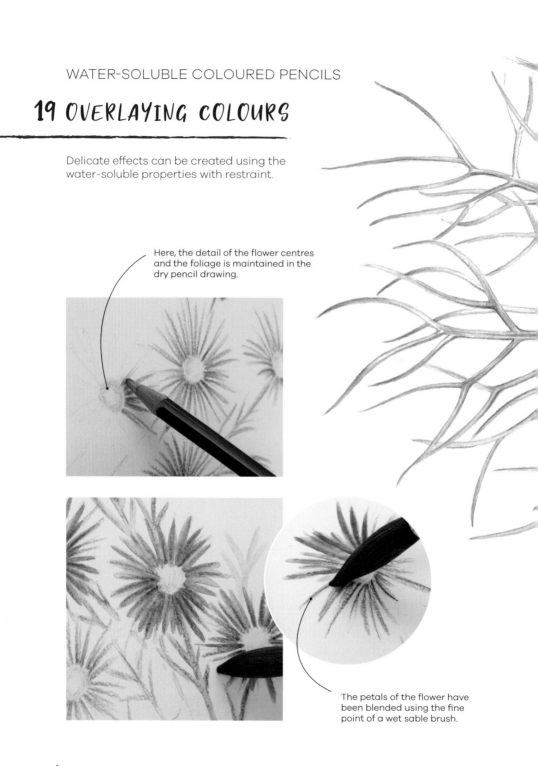

Here, the detail of the flower centres and the foliage is maintained in the dry pencil drawing.

The petals of the flower have been blended using the fine point of a wet sable brush.

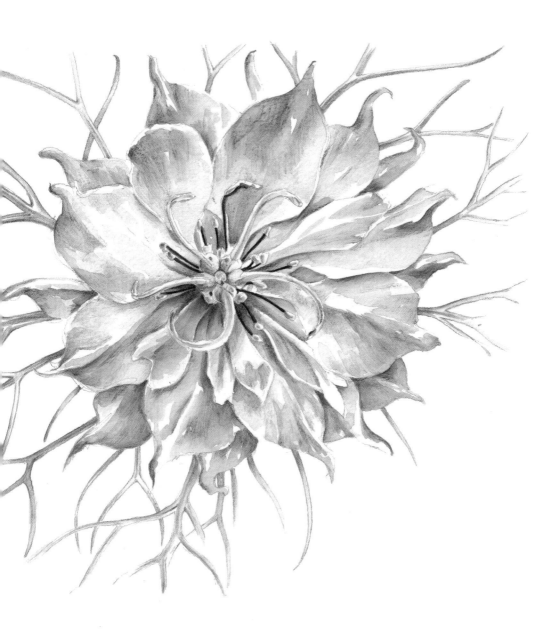

Turpentine or white spirit are alternative wetting agents to water. They dry fast and do not spread in the same way so are more easily controlled. Dipping the point of a paper torchon into these liquids will soften small areas of colour.

LINEAR MARKS, TONE, HATCHING
20 AND CROSS HATCHING

Charcoal pencils are more controllable than charcoal sticks and can produce fine lines. Thin sticks of willow charcoal can produce equally delicate drawings with practise.

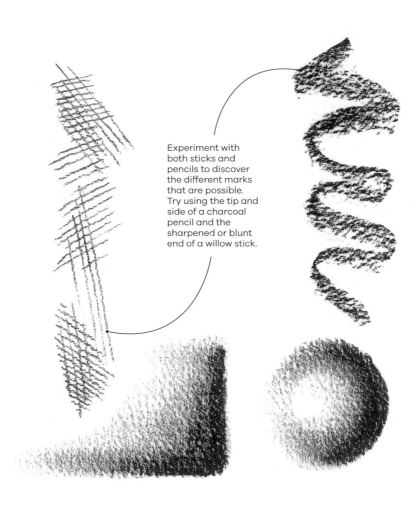

Experiment with both sticks and pencils to discover the different marks that are possible. Try using the tip and side of a charcoal pencil and the sharpened or blunt end of a willow stick.

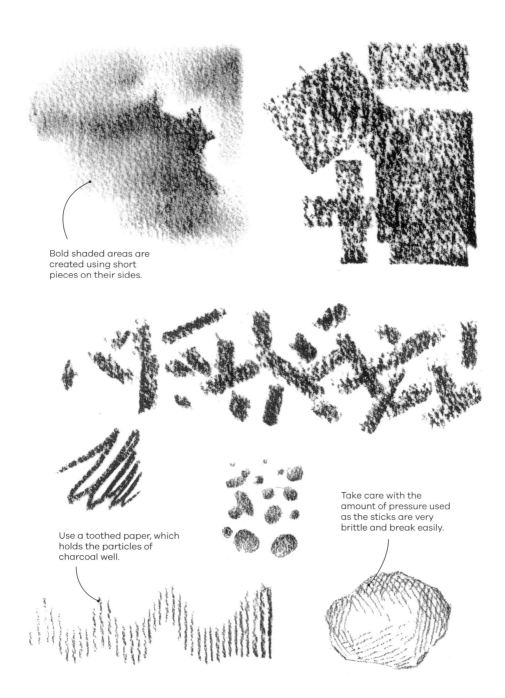

Bold shaded areas are
created using short
pieces on their sides.

Use a toothed paper, which
holds the particles of
charcoal well.

Take care with the
amount of pressure used
as the sticks are very
brittle and break easily.

SHADING, BLENDING
21 AND HIGHLIGHTS

With experience charcoal can be used to create a variety of subtle effects. These drawings were done on smooth paper.

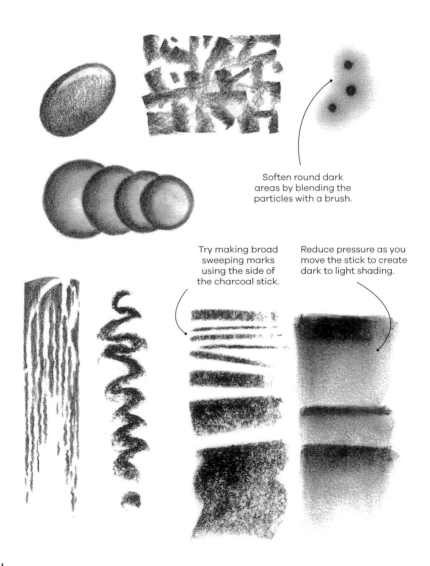

Soften round dark areas by blending the particles with a brush.

Try making broad sweeping marks using the side of the charcoal stick.

Reduce pressure as you move the stick to create dark to light shading.

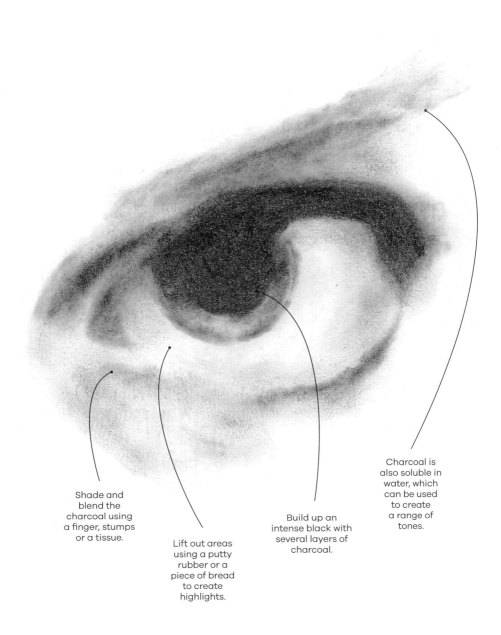

Shade and blend the charcoal using a finger, stumps or a tissue.

Lift out areas using a putty rubber or a piece of bread to create highlights.

Build up an intense black with several layers of charcoal.

Charcoal is also soluble in water, which can be used to create a range of tones.

EFFECTS ON SMOOTH
22 OR TEXTURED PAPER

This sketch was drawn over four different types of paper, starting on the smoothest cartridge drawing paper and then over three watercolour papers with slightly different surface patterns. This shows how the choice of paper alters the effect of the charcoal.

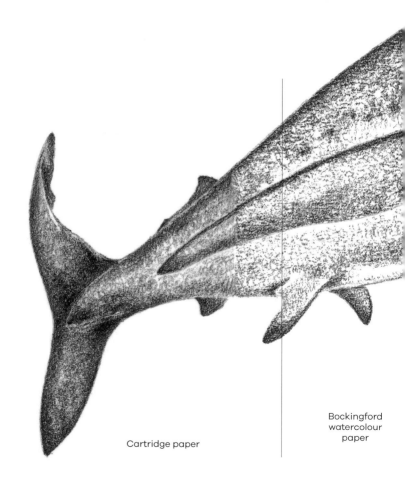

Cartridge paper

Bockingford
watercolour
paper

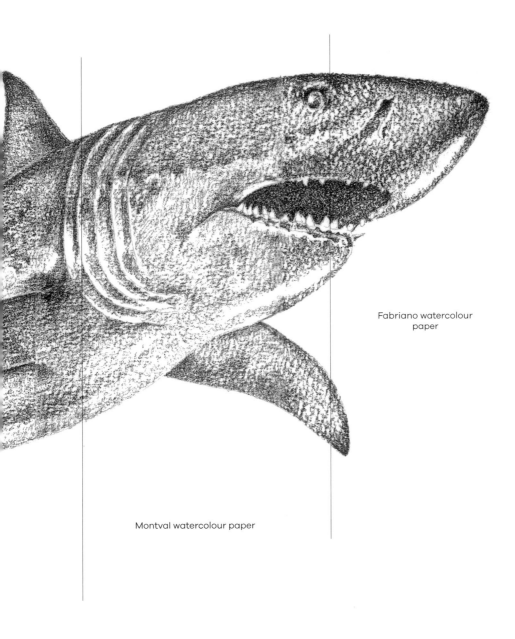

Fabriano watercolour
paper

Montval watercolour paper

23 LINEAR MARKS AND TONE

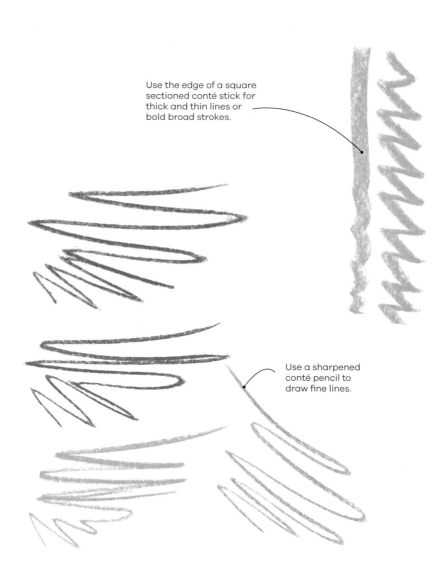

Use the edge of a square sectioned conté stick for thick and thin lines or bold broad strokes.

Use a sharpened conté pencil to draw fine lines.

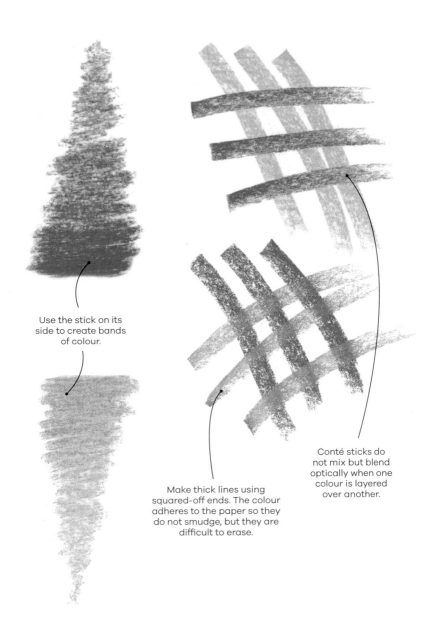

Use the stick on its side to create bands of colour.

Make thick lines using squared-off ends. The colour adheres to the paper so they do not smudge, but they are difficult to erase.

Conté sticks do not mix but blend optically when one colour is layered over another.

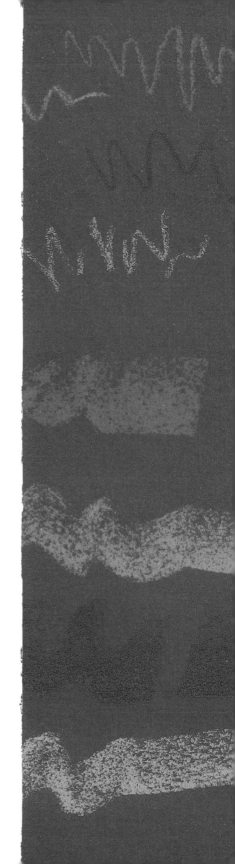

USING COLOURED
24 SUPPORTS

The brighter and lighter colours are best used on tinted papers with a rough texture. The support used here is a sandpaper type suitable for pastels. The depth of colour depends on the pressure used.

Conté sticks are harder than pastels and contain a greater pigment density. They can also be used on prepared primed canvasses for underdrawing for a painting.

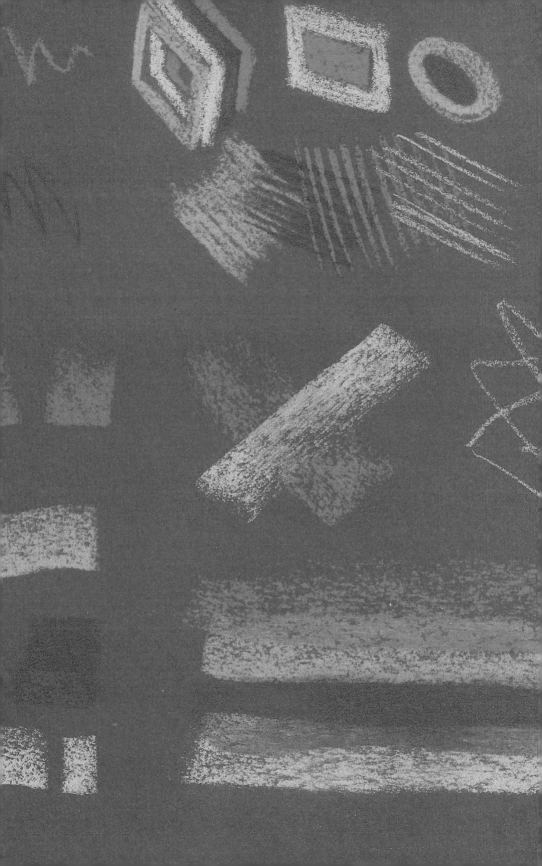

25 TEXTURES

Using textured papers such as pastel paper, Mi-Teintes or a rough watercolour paper, as shown here, breaks up the colour and introduces flecks of white or whatever the background tint is.

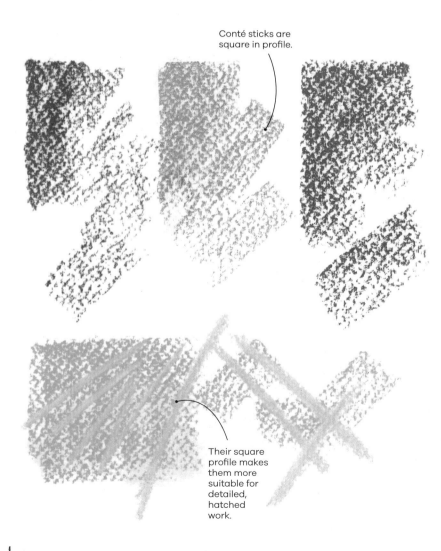

Conté sticks are square in profile.

Their square profile makes them more suitable for detailed, hatched work.

They are used for drawing, generally on a rough paper that holds pigment grains well.

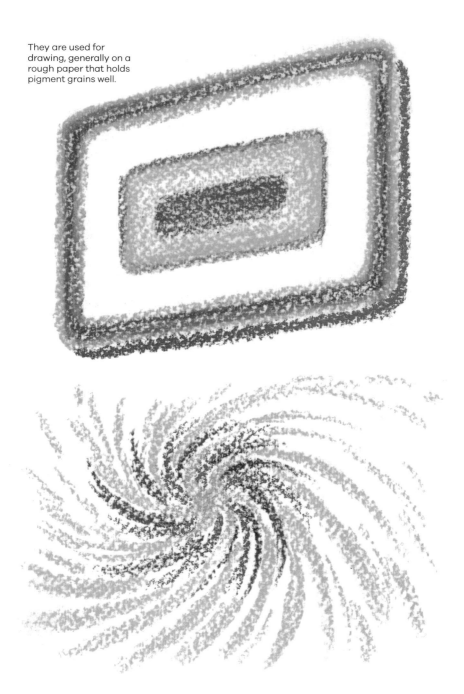

26 LINEAR MARKS AND TONES

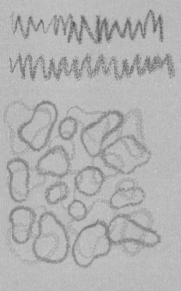

- Pastel pencils are used for drawing or to add detail to a pastel painting.

- They are perfect for preliminary sketching and for adding hatching, fine lines, shading and detail to a finished drawing.

- Their hardness is midway between soft and hard pastels.

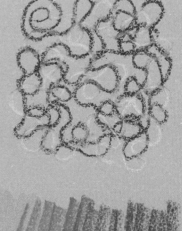

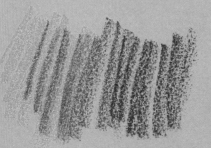

LINEAR MARKS AND TONES 27

- Chalks are best used on toned paper.
- A slight tooth to the paper helps the chalk particles adhere to the surface.

28 EXPRESSIVE DRAWING

The preliminary drawing of this elephant was done with a brown pastel pencil on rough paper. The colour was added using chalks. The pale areas of colour in the background were created using chalk and blended with a finger. The final details such as the eye, folds of skin and trunk were added using pastel pencils in different colours.

- Pastel pencils provide a practical alternative to soft pastels.

- Pastel pencils can be sharpened like an ordinary pencil and are used in much the same way so they will give precise, firm lines. They can be freely used with conventional soft and hard pastels.

- Rough paper is excellent for a loose, expressive style of drawing.

- You can use chalk for an outstanding sweeping effect.

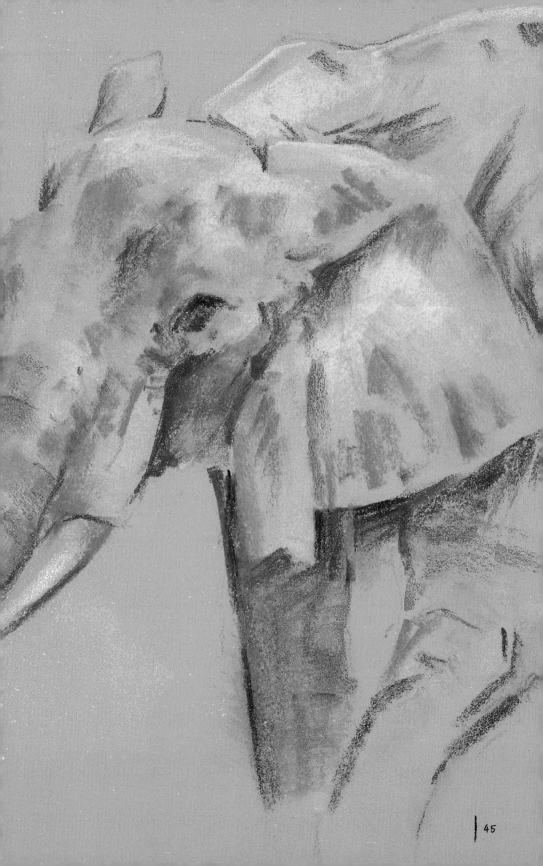

45

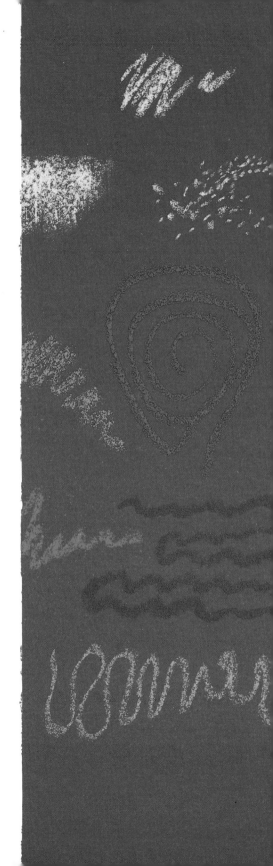

LINEAR MARKS
29 AND TONES

- These crumbly sticks are almost pure pigment. Draw using the end for a soft, expressive line.

- Crumbled up, the colour particles can be worked with a finger or shaper.

- The harder you press, the thicker the mark will be.

- Use the edge of a broken end for fine lines and break them into short lengths for shading using the sides. Try drawing loosely with your whole arm, not just from the wrist.

- The marks shown here were made on a sheet of tinted fine pastel sandpaper.

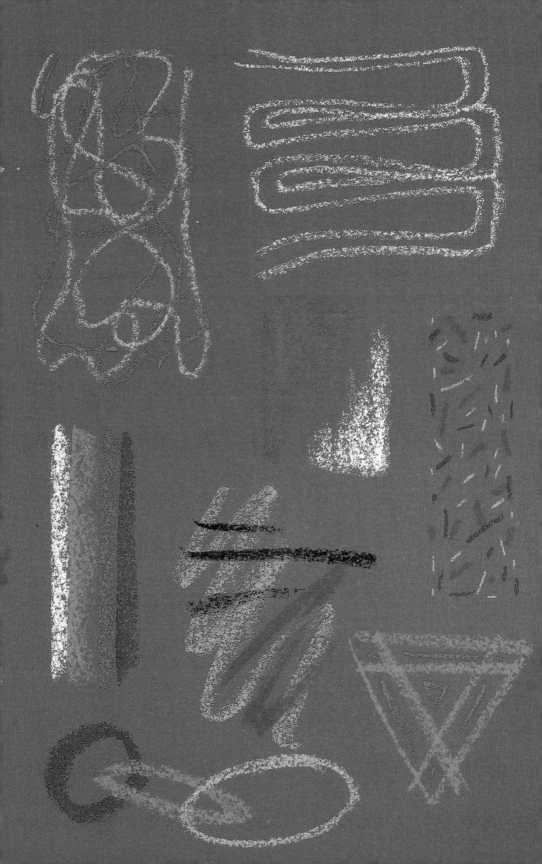

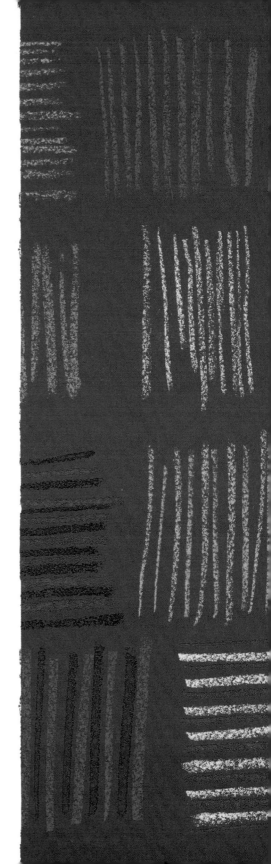

TEXTURED
30 SUPPORTS

Fine sandpaper and velour paper are very different to traditional pastel papers. Try them out using a series of marks to see how firmly they hold the pigment. It is not easy to blend colours on these papers and they use up pastels quite quickly.

- Hold a pastel stick flat on the support and drag it lengthways down the paper to produce a line or parallel lines.

- Hatch in two or more colours to give an impression of continuous colour.

- Vary the thickness of the lines and the pressure used when hatching to obtain variations.

This cloudscape was created on pastel sandpaper. The final effect resembles an oil painting.

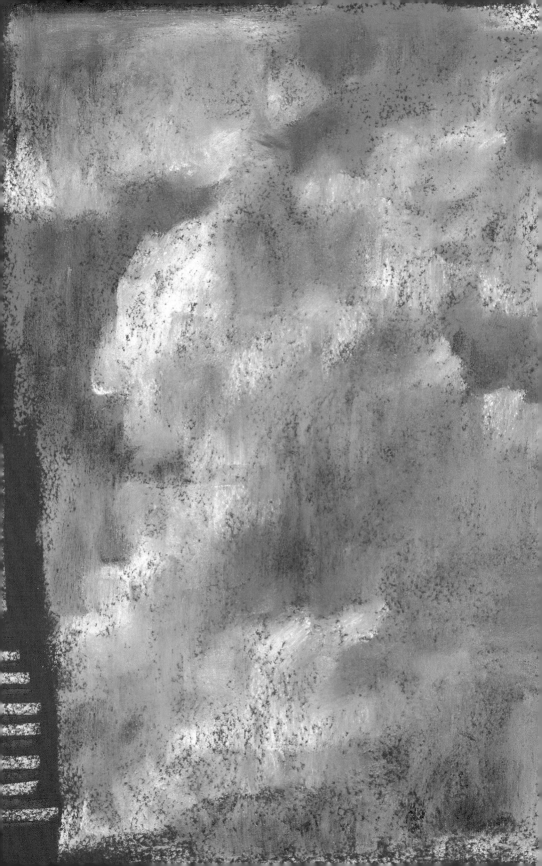

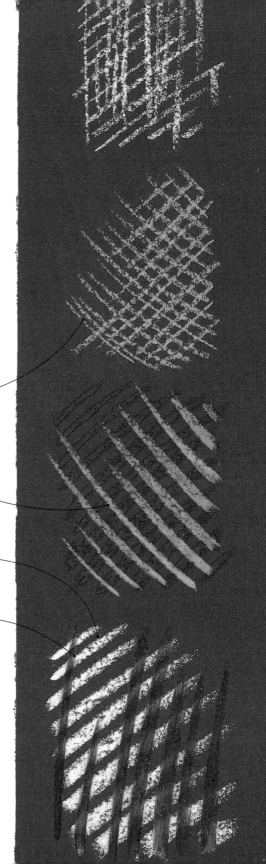

COLOUR
31 BLOCKING

Cross hatching can be done
using a single colour or two or
more colours. This is a useful
way of building up tone or to
block in a drawing quickly.

Feathering, a variation
on hatching, is achieved
using shorter strokes
following the shape of
an object.

Follow the contours of
an object using curved
hatching lines.

By varying the direction
of the cross hatching a
sense of form and shape
can be created.

Lift the stick at the end
of a stroke for a lively
impression.

These pebbles were drawn using the sides of
the pastels and then blended with a finger.

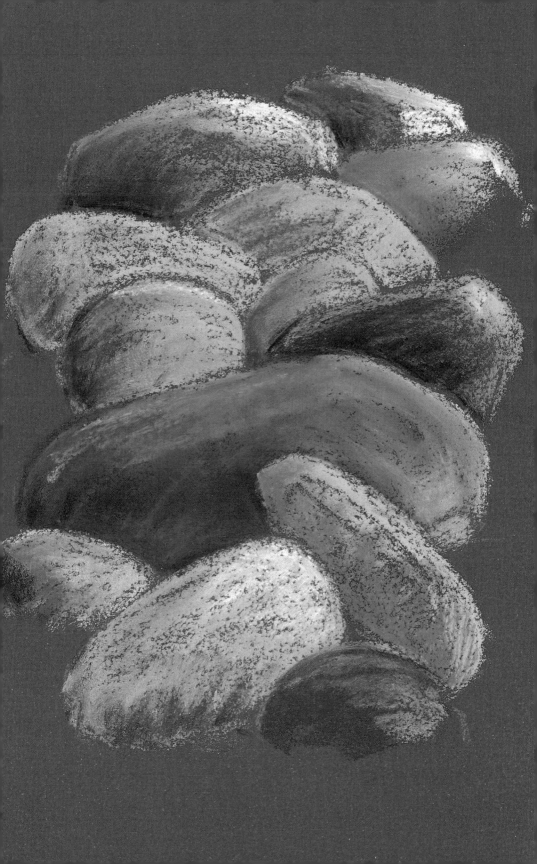

BLENDING ON SANDPAPER, 32 TEXTURED PAPER AND CARDBOARD

Create variations in colour and tone by blending with fingers, torchons, rags, cotton buds or a putty rubber. Try spreading the colours using a brush dipped in water to create a wash or to soften lines. Scrape a pastel stick over an area of colour and press the dust into the surface for a stippled effect.

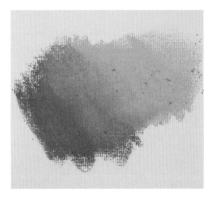

Experiment by trying out other supports such as a smooth cardboard sheet.

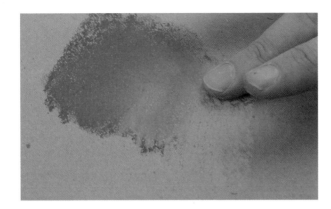

Pastel paper has a characteristic fine-line texture.

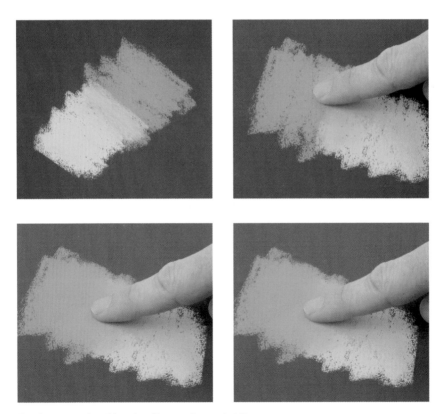

Good coverage is achieved on fine sandpaper but it uses up pastels fast.

33 SCUMBLING

The bright colours of pastels lend
themselves to the technique of
scumbling. Using the side of the pastel,
lightly drag it over the first layer of colour.
The effect is very textural.

Black pastel with a colour
scumbled on top adds depth.

Light colour over dark
gives a shimmer effect.

A lighter colour over dark is
most effective and the second
layer can be worked in parallel
stripes or shaded in several
directions.

Close toned colours
mix optically.

BROKEN EDGES

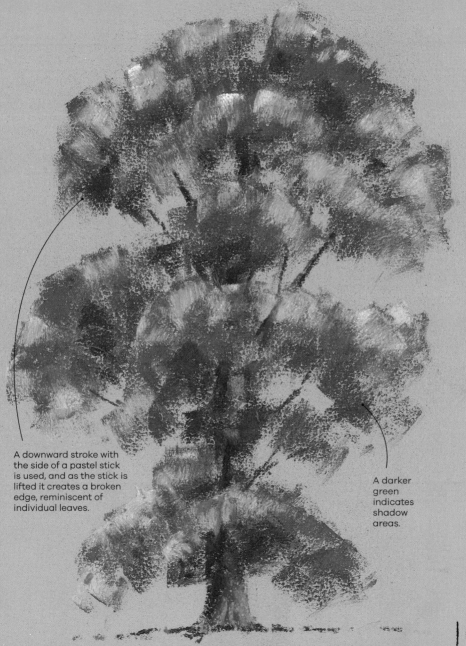

A downward stroke with the side of a pastel stick is used, and as the stick is lifted it creates a broken edge, reminiscent of individual leaves.

A darker green indicates shadow areas.

35 BASIC MARK MAKING

The binder content is considerably higher in hard pastels, which makes them easy to sharpen and less likely to break. This quality makes them more suitable for linear work as the variety of marks here shows. The sides can be used to block in large areas of colour, which can then be worked over, as shown opposite.

- Hard pastels have more binder and less pigment yet this doesn't necessarily make them inferior.

- They are also good for underpainting or outlining prior to overlaying with soft pastels.

- Hard pastels come in a wide range of colours – both pale and extremely vivid

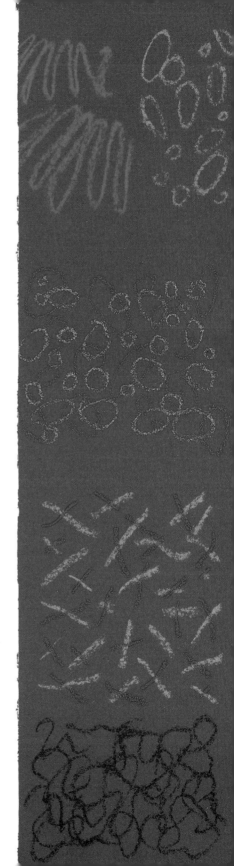

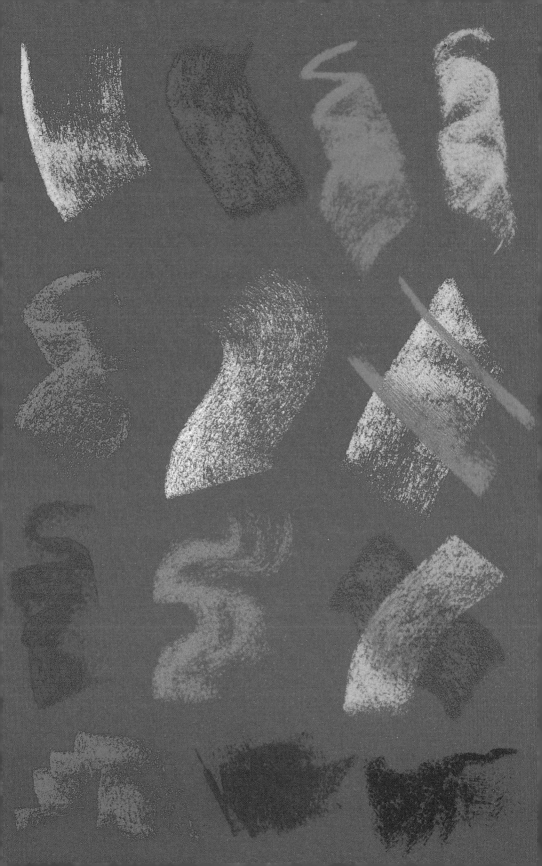

HATCHING AND
36 CROSS HATCHING

Vary the pressure to create lights and darks.

Wavy parallel lines add texture.

Hatching in two or more shades builds up colour using the linear quality of the pastels.

The range of colours of hard pastels is limited and they do not blend easily.

OVERLAYING COLOURS

As a general rule, work from dark to light.

Use a tinted support and select one to complement the subject. A neutral beige sheet was chosen for this stonewashed barn.

Make your own tinted paper with a watercolour wash but stretch the paper to avoid buckling.

38 SCUMBLING AND SGRAFFITO

Experiment to create different effects such as scratching out and scumbling, where a pastel is dragged over an area of colour, or try light pastels worked over dark and vice versa.

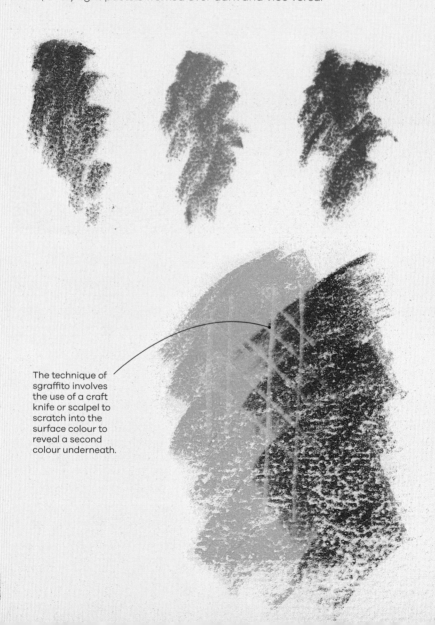

The technique of sgraffito involves the use of a craft knife or scalpel to scratch into the surface colour to reveal a second colour underneath.

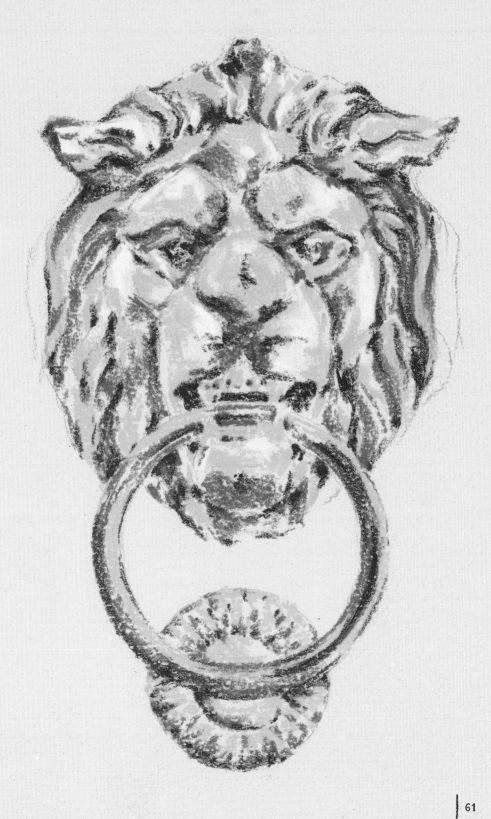

39 LINEAR MARKS AND TONE

Most crayon sets have a limited colour range and they do not blend easily. An optical colour mixing effect is created using hatching and cross hatching. Frottage, where crayon is rubbed over a textured surface placed under the support, gives interesting results. Wax crayons are useful as a resist when using wet media such as watercolour pencils.

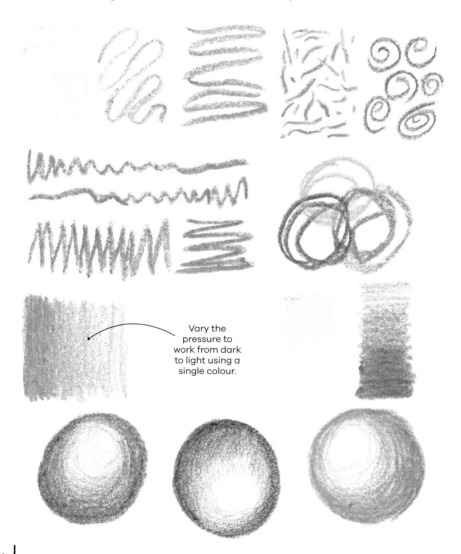

Vary the pressure to work from dark to light using a single colour.

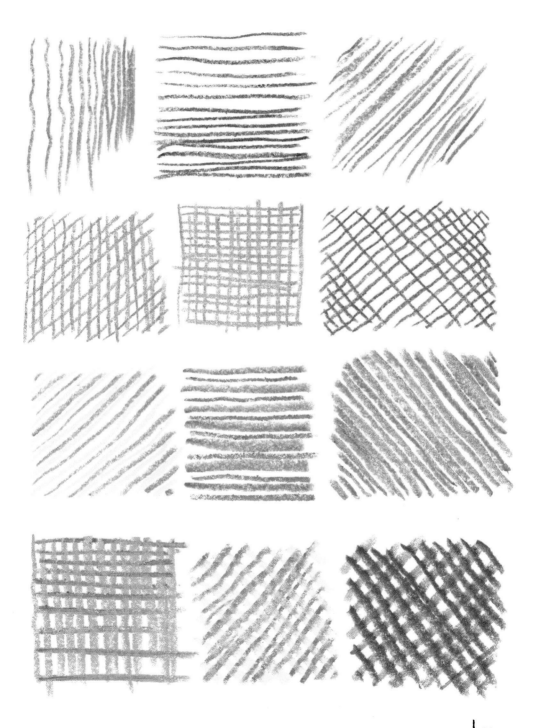

BLENDING, SHADING
40 AND SGRAFFITO

Some colour mixing occurs when
one colour is used over another.

When layered, some
colour blending can be
achieved and varying
the amount of pressure
gives a range of shades
from light to dark.

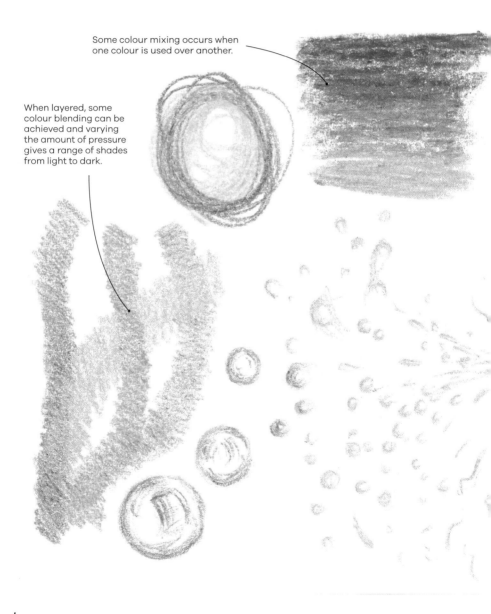

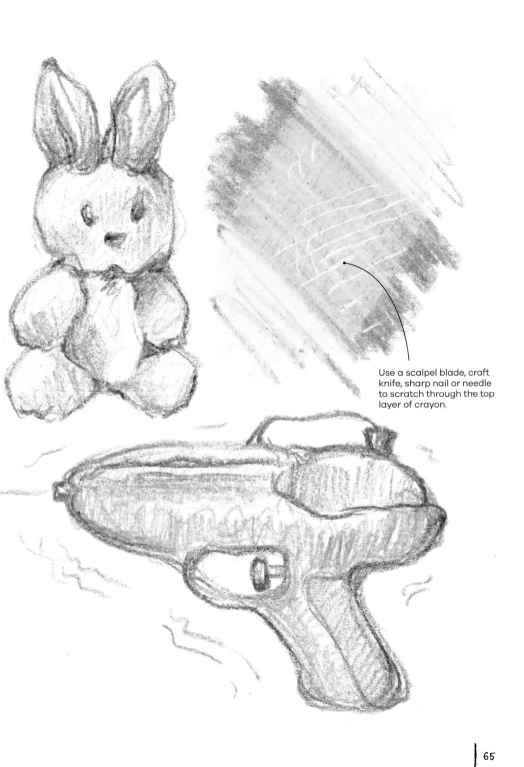

Use a scalpel blade, craft knife, sharp nail or needle to scratch through the top layer of crayon.

LINEAR MARKS WITH
41 NIBS AND HATCHING

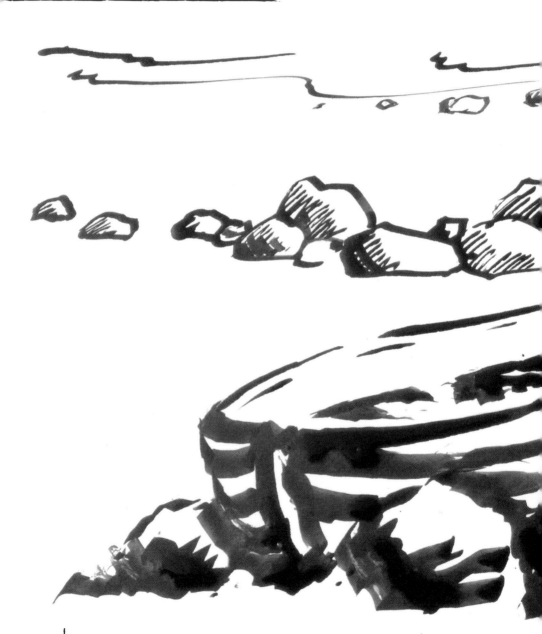

No 5½ fine nib for fine lines in the distance.

No 5 medium nib.

No 3½ thick nib for objects in the foreground.

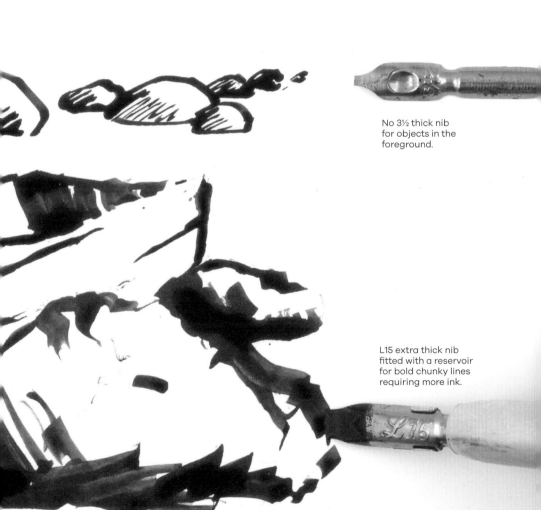

L15 extra thick nib fitted with a reservoir for bold chunky lines requiring more ink.

42 WATERPROOF INKS

For detailed drawings, a sketching pen, mapping pen or dip pen with a nib size 5 or 6, is ideal. Use a smooth paper surface so that the pen can move quickly and easily over it. Illustration board, Bristol board or HP watercolour papers are ideal. If the paper is sized internally or on the surface (see page 99), the ink line will not spread and colours will appear bright.

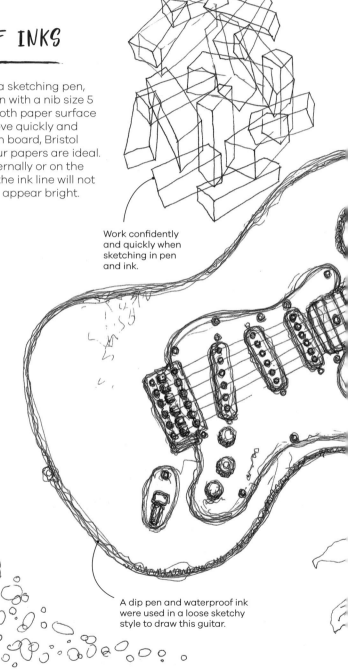

Work confidently and quickly when sketching in pen and ink.

Doodle to get to know how much ink your nibs hold. You cannot re-charge your pen when creating a flowing unbroken line.

A dip pen and waterproof ink were used in a loose sketchy style to draw this guitar.

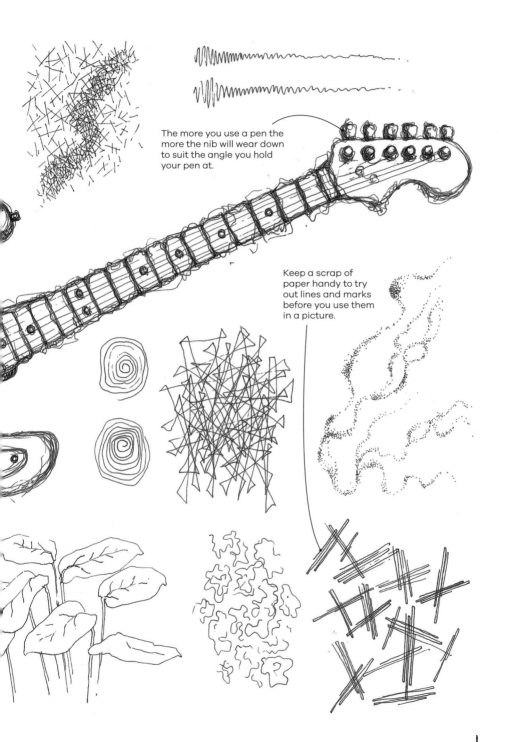

The more you use a pen the more the nib will wear down to suit the angle you hold your pen at.

Keep a scrap of paper handy to try out lines and marks before you use them in a picture.

43 WATER-SOLUBLE INKS

Water-soluble inks are available in many colours.
They are fast drying and transparent, which allows
them to be overlaid for optical colour mixing.

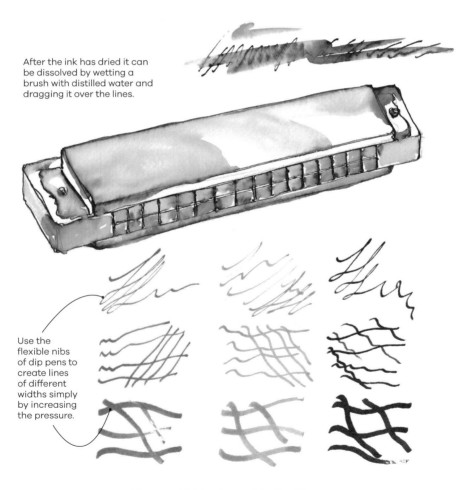

After the ink has dried it can
be dissolved by wetting a
brush with distilled water and
dragging it over the lines.

Use the
flexible nibs
of dip pens to
create lines
of different
widths simply
by increasing
the pressure.

Dip pens with interchangeable nibs offer a range
of widths. Sizes 0, 1, 1½, 2, 2½, 3, 3½, 4, 5 and 6, the
finest, are sold as sets or individually.

PAINTING EFFECTS 44

Water-soluble inks can also be used to paint with.

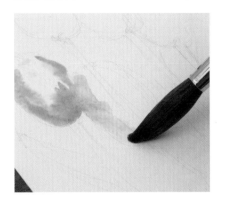

Dip a clean brush into the ink to charge it with colour. Some inks come with a dropper in the lid.

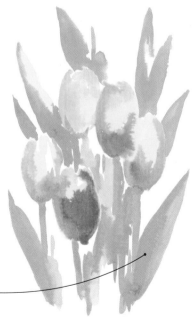

Drip the colour on to the support and then use a clean brush to spread it.

Achieve a range of tones simply by adding water.

45 ACRYLIC INK, LINEAR MARKS

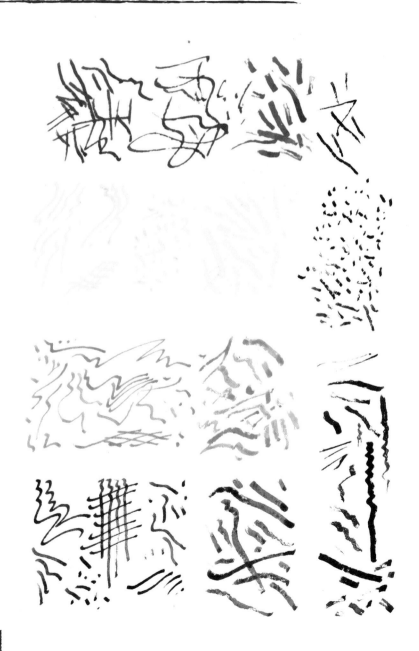

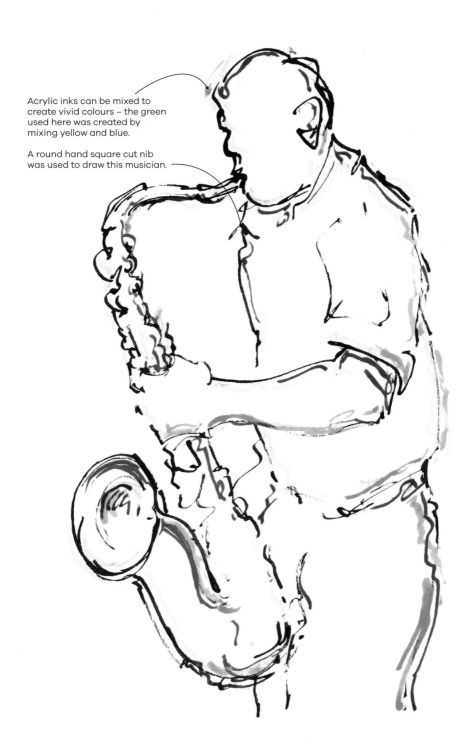

Acrylic inks can be mixed to create vivid colours – the green used here was created by mixing yellow and blue.

A round hand square cut nib was used to draw this musician.

46 CUTTING A QUILL PEN

Traditionally goose feathers are cut to make quill pens but swan and turkey feathers can also be used.

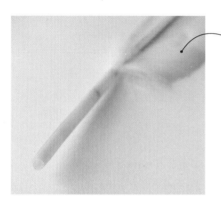

Goose feathers should be cured for a year before the nibs are cut. Trim the length to about 25cm (10in) and strip the barbs leaving about 2–3cm (1–1½in) at the end.

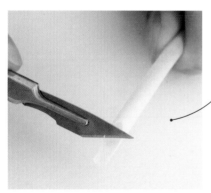

Use a scalpel with a sharp blade to cut the nib end off square and then make a 25-degree angle cut approximately 1cm (½in) long.

Cut a channel down the centre of the nib very carefully to avoid splitting the shaft. For a finer nib, trim the sides until you have the width of nib you require.

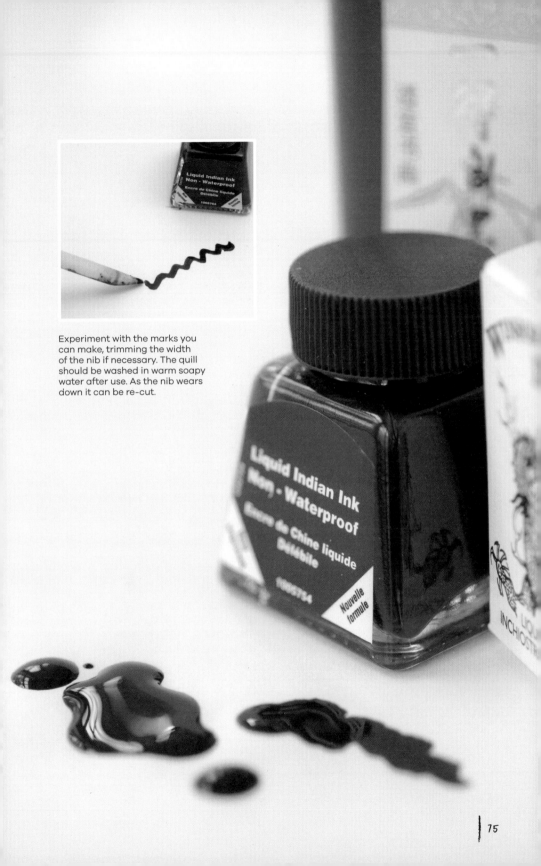

Experiment with the marks you can make, trimming the width of the nib if necessary. The quill should be washed in warm soapy water after use. As the nib wears down it can be re-cut.

47 TONE AND TEXTURE

The fine line of a ballpoint pen can look mechanical, but tones and textures can be created using hatching, cross hatching or scribbles, where randomly created marks are built up to create depth.

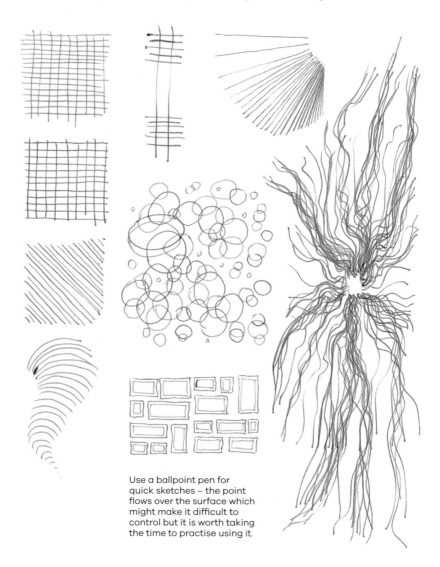

Use a ballpoint pen for quick sketches – the point flows over the surface which might make it difficult to control but it is worth taking the time to practise using it.

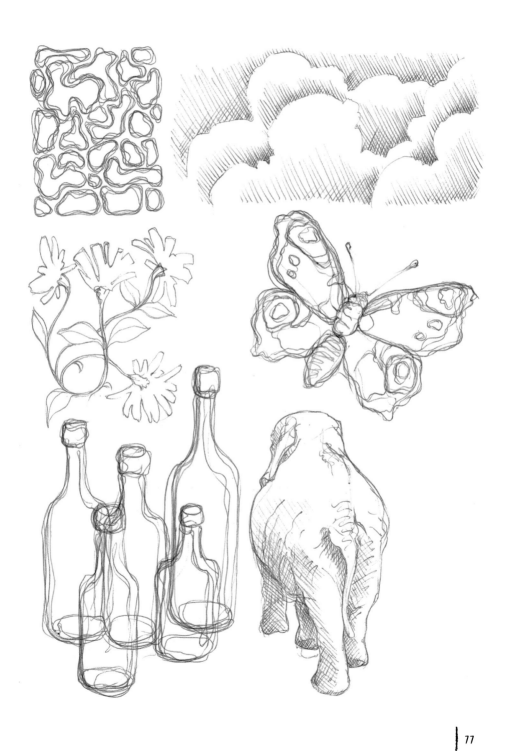

48 SHADING AND DEPTH

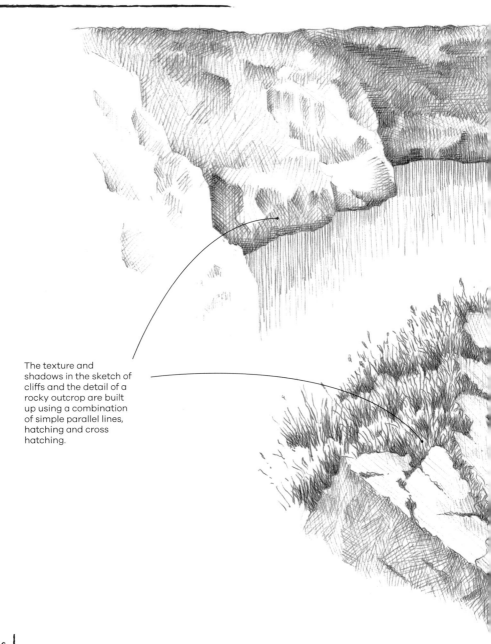

The texture and shadows in the sketch of cliffs and the detail of a rocky outcrop are built up using a combination of simple parallel lines, hatching and cross hatching.

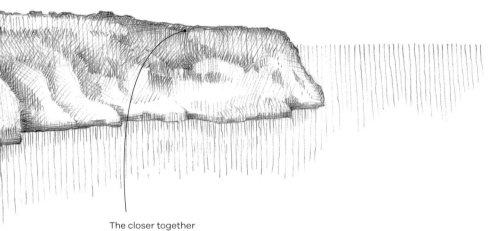

The closer together
the lines are, the
darker the area
appears.

The light and dark planes
of the rocks are simply
achieved by varying the
density of spacing of the
hatched lines.

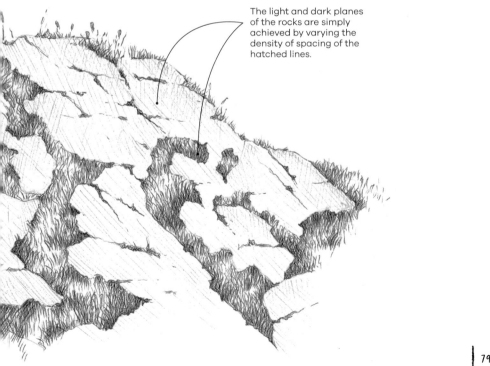

49 LINEAR MARKS

For quick sketches in bold bright colours, marker pens produce flowing lines. Use a paper that prevents the colour from bleeding or marking the sheet underneath.

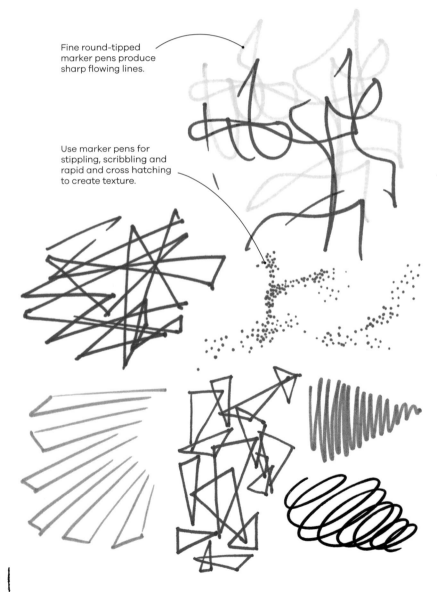

Fine round-tipped marker pens produce sharp flowing lines.

Use marker pens for stippling, scribbling and rapid and cross hatching to create texture.

Wedge-shaped marker pens can make both thick and thin stokes.

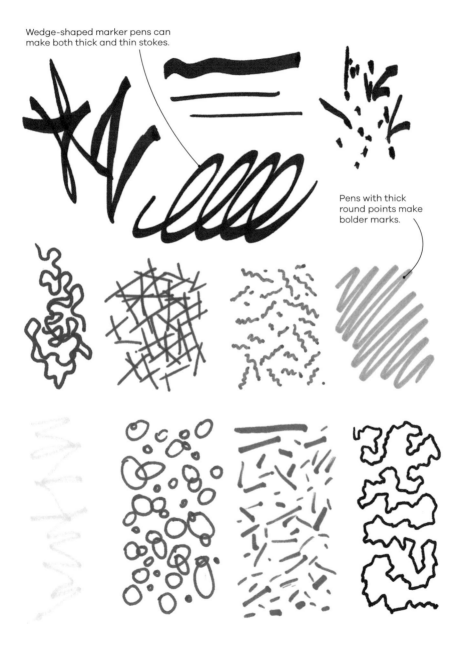

Pens with thick round points make bolder marks.

50 BLENDING EFFECTS

The colours are transparent and colour mixing is possible when they are layered.

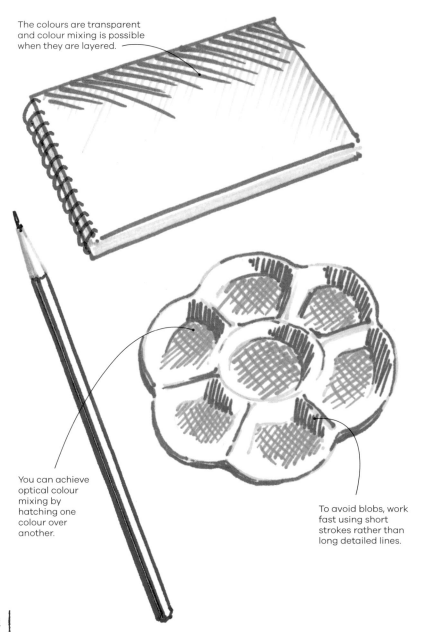

You can achieve optical colour mixing by hatching one colour over another.

To avoid blobs, work fast using short strokes rather than long detailed lines.

Work quickly – resting the pen tip on the paper will leave a blotch, which may spread.

Experiment by combining pens from different manufacturer's in the same drawing.

LINEAR MARKS IN ONE 51 AND TWO COLOURS

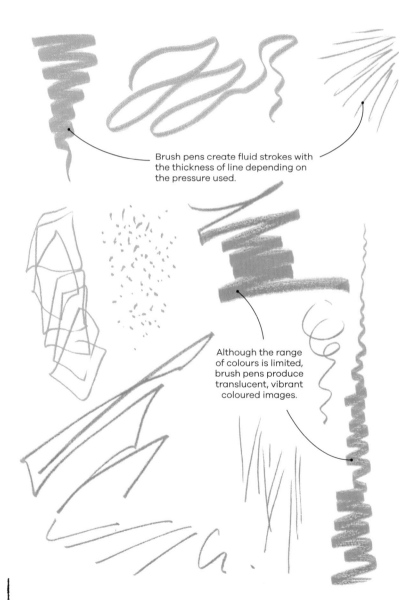

Brush pens create fluid strokes with the thickness of line depending on the pressure used.

Although the range of colours is limited, brush pens produce translucent, vibrant coloured images.

The synthetic brush retains its shape and lines of different thickness are achieved by just using the tip or the whole length of the brush.

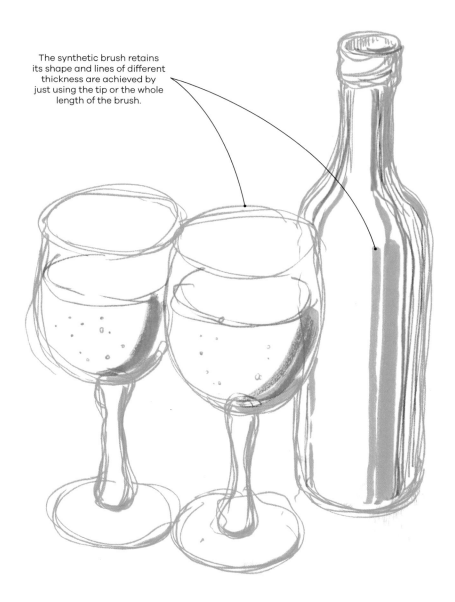

CROSS HATCHING,
52 DRAWING AND MARKS

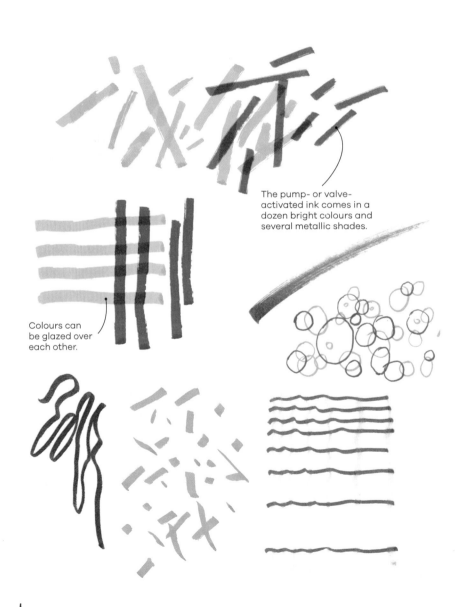

The pump- or valve-activated ink comes in a dozen bright colours and several metallic shades.

Colours can be glazed over each other.

Experiment with overlaid marks
to create different shades.

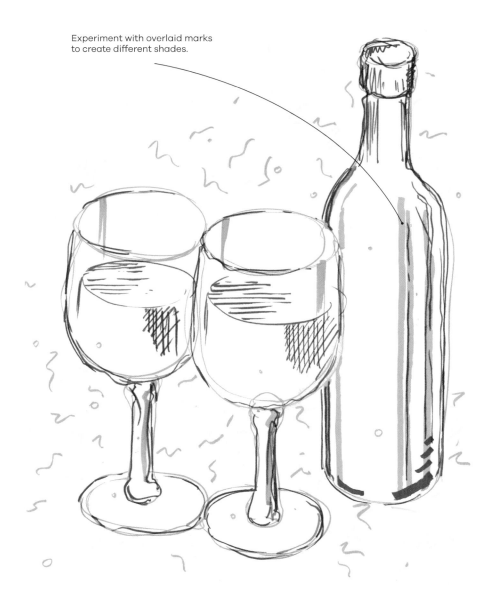

OIL PASTELS

53 LINE AND COLOUR

These vivid colours are ideal for
bold bright drawings. They are not
as crumbly as soft or hard pastels
and you can work on almost any
support from paper to card.

Oil pastels cover the
support well with a
rich creamy finish.

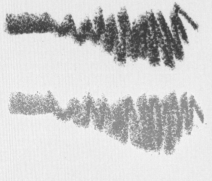

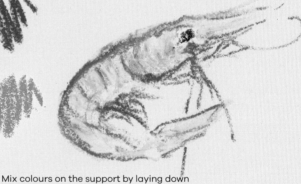

Mix colours on the support by laying down
the first colour and then blending in the
second. Clean the pastel after blending.

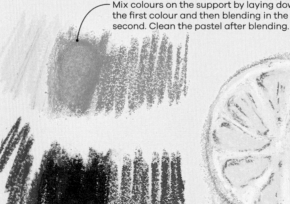

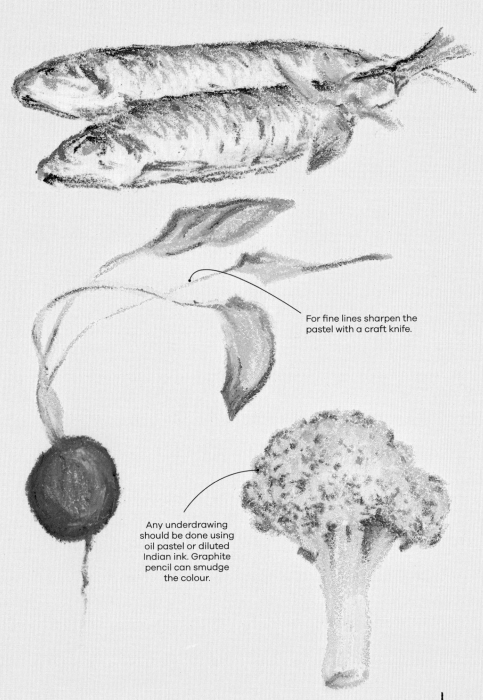

For fine lines sharpen the pastel with a craft knife.

Any underdrawing should be done using oil pastel or diluted Indian ink. Graphite pencil can smudge the colour.

54 TONE AND SCUMBLING

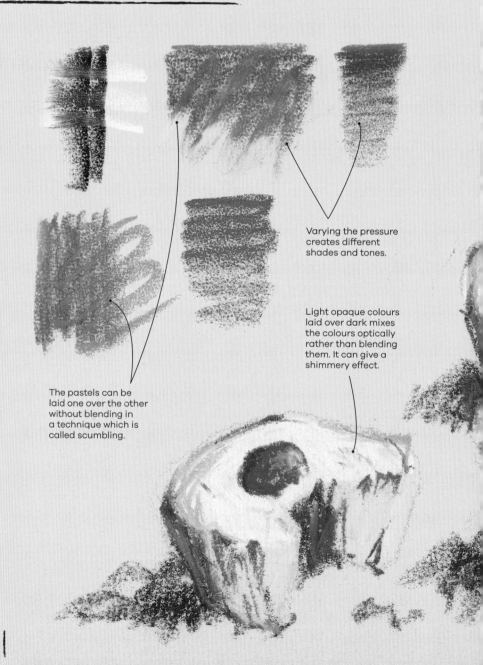

Varying the pressure creates different shades and tones.

Light opaque colours laid over dark mixes the colours optically rather than blending them. It can give a shimmery effect.

The pastels can be laid one over the other without blending in a technique which is called scumbling.

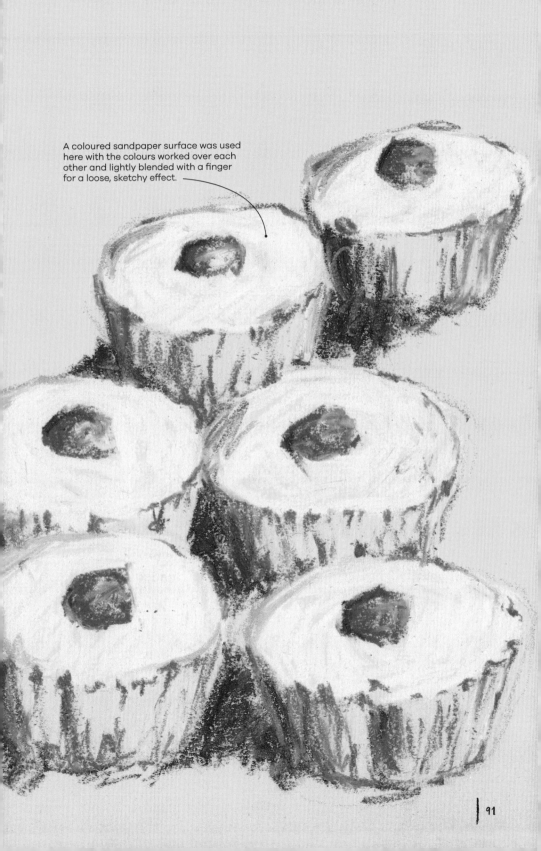

A coloured sandpaper surface was used here with the colours worked over each other and lightly blended with a finger for a loose, sketchy effect.

55 BLENDING

Mix colours directly on the support, building up a rich layer of colour and blend them using a finger or a rag or brush dipped into white spirit or turpentine. Building up the colour in this way gives an effect similar to oil paints.

- A background support similar in colour to the subject was used for this drawing of chocolates. Test the pastels on a scrap of paper before using a coloured support so that you can check the effect.

- Store oil pastel drawings interleaved with sheets of paper and keep them away from heat sources or direct sunlight, which can melt the colours.

Try using a hog's hair brush dipped in turps to pick up paint from an oil pastel stick to stipple on the surface. Alternatively dip the stick itself into turps before using it to blend with other colours in the drawing.

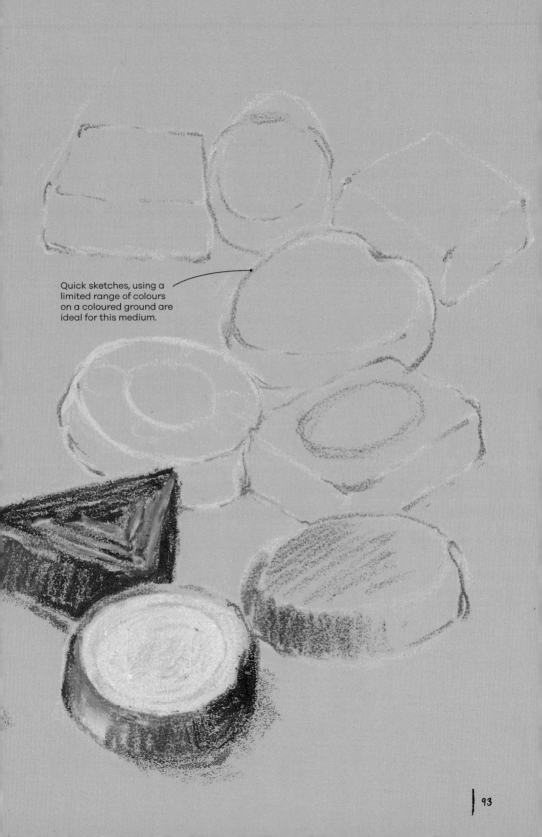

Quick sketches, using a limited range of colours on a coloured ground are ideal for this medium.

56 LAYERING

Oil pastels can be combined with other media,
apart from pastels. They do not need fixing. The
oil content makes them useful as a resist, and
building up layers creates a bold, vibrant image.

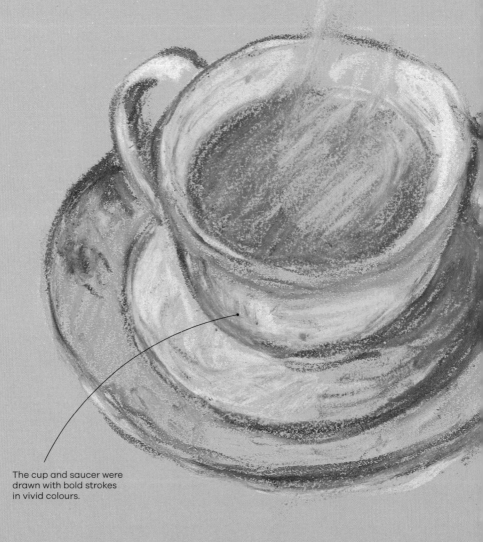

The cup and saucer were
drawn with bold strokes
in vivid colours.

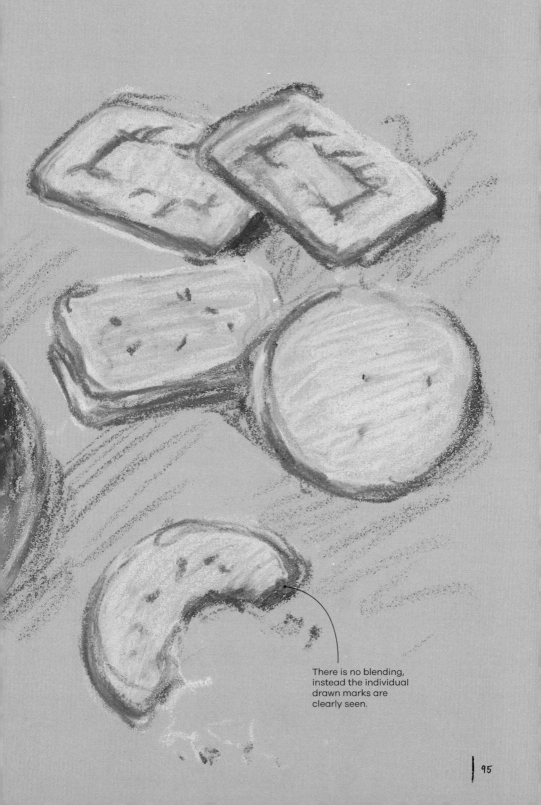

There is no blending,
instead the individual
drawn marks are
clearly seen.

OIL PAINT STICKS

57 MARKS FOR TEXTURE

These thick, soft sticks can create the effect of an oil painting. Use them on a variety of surfaces including paper, canvas, cloth, glass or even ceramic.

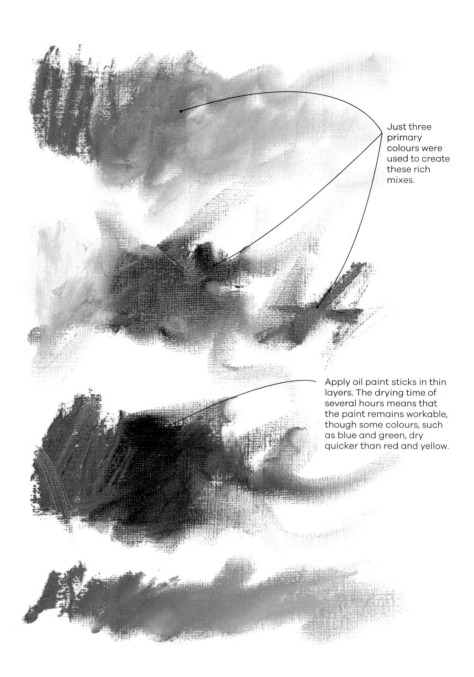

Just three primary colours were used to create these rich mixes.

Apply oil paint sticks in thin layers. The drying time of several hours means that the paint remains workable, though some colours, such as blue and green, dry quicker than red and yellow.

OIL PAINT STICKS

58 QUICK SKETCHING

Use oil paint sticks to create quick, spontaneous sketches and bold painterly effects; they are not suitable for fine-line sketching or detailed drawing.

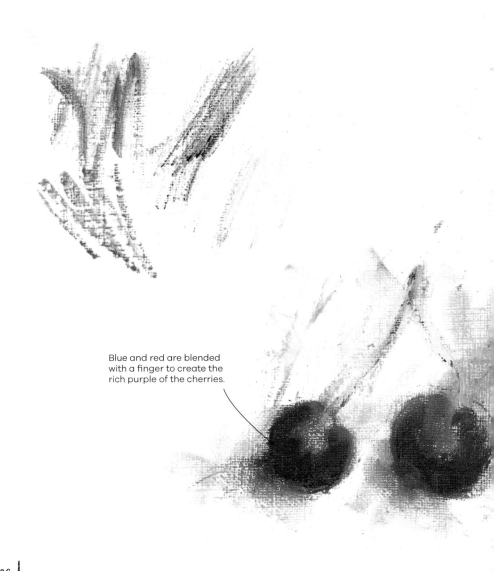

Blue and red are blended with a finger to create the rich purple of the cherries.

The support is a canvas
textured paper, which reinforces
the look of an oil painting.

White highlights are
added here and there.

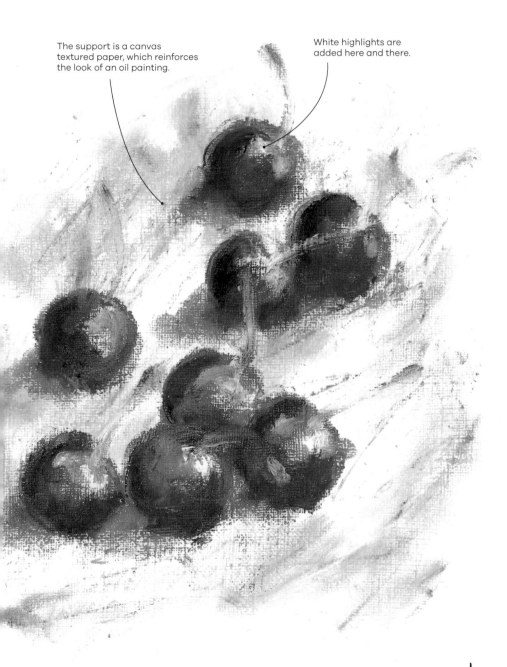

59 IMPASTO

The paint can be built up to impasto thickness and worked with a palette knife. The thicker the paint the longer it will take to dry. Other factors affecting the drying time include temperature and humidity. The image should be fully dry within three days and can be varnished after six months.

- Paint is laid on an area of the surface very thickly, usually thick enough for the brush or painting-knife strokes to be visible.

- Oil paint is most suitable to the impasto painting technique, due to its thickness and slow drying time.

- Acrylic paint can also be impastoed.

- Impasto can add expressiveness to the painting.

- Impasto makes the light reflect in a particular way, giving you additional control over the play of light on the painting.

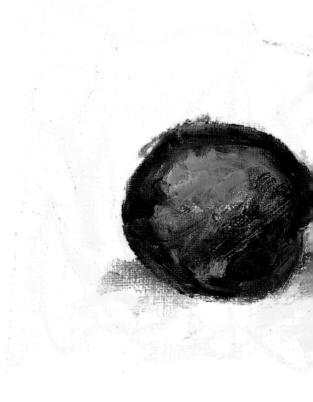

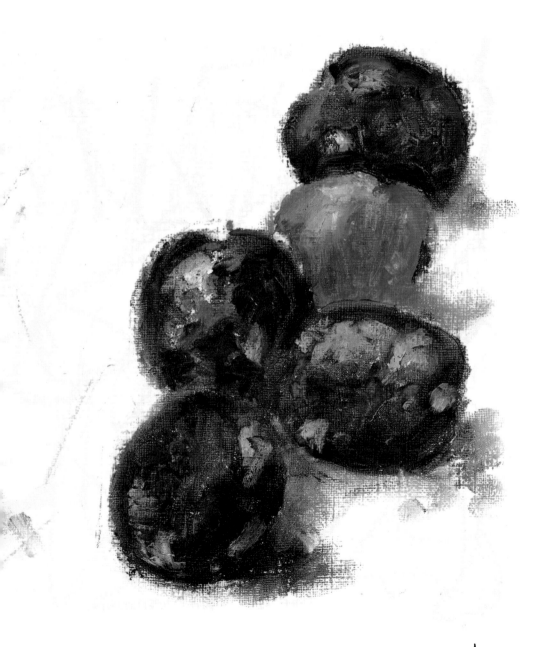

60 SGRAFFITO

A thick layer of colour is ideal for
scratching out or sgraffito. Washes
of colour can also be created using
turpentine or white spirit spread over
the oil paint with a rag or brush.

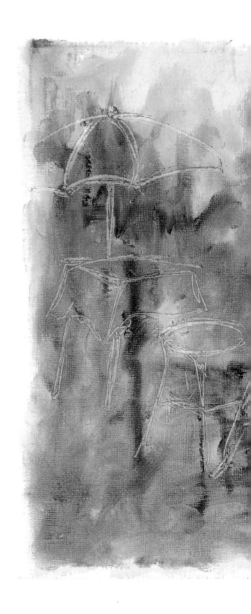

The background was created by smudging yellow, blue and red oil paint sticks all over the canvas-effect support.

The detailed drawing of tables and chairs were scratched out using a sharp stick.

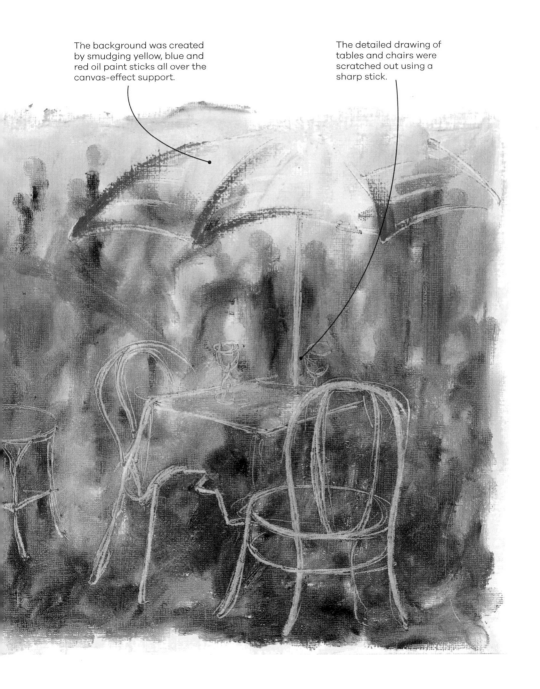

GRAPHITE, COLOURED
61 AND WATERCOLOUR PENCILS

Graphite pencils are commonly used for the initial sketch, which is then worked up in another medium. Take care when using them with coloured or watercolour pencils as the graphite lines can show through. Minimize this by erasing the lines gently to lighten the drawing.

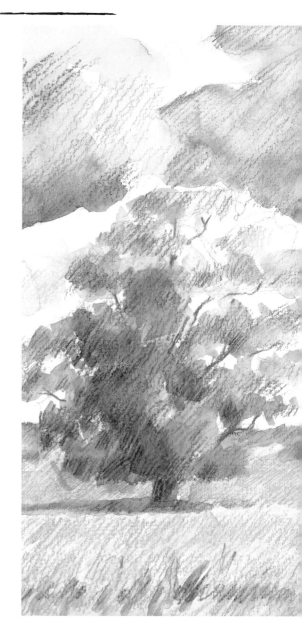

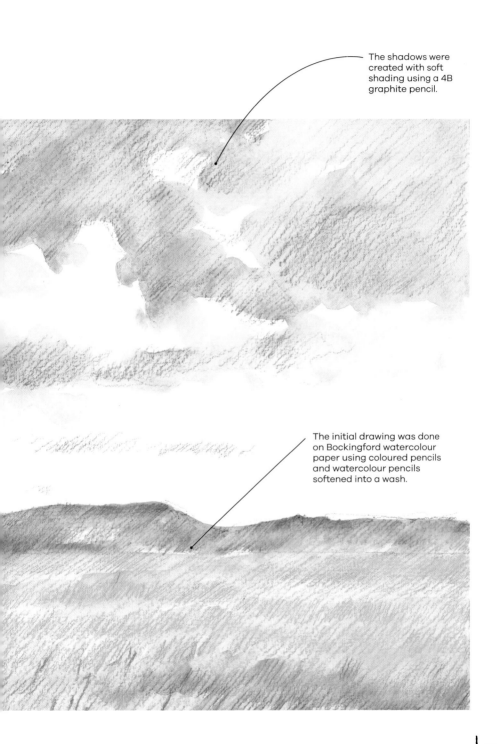

The shadows were created with soft shading using a 4B graphite pencil.

The initial drawing was done on Bockingford watercolour paper using coloured pencils and watercolour pencils softened into a wash.

62 GRAPHITE PENCILS, SOFT PASTELS AND CHARCOAL

This cityscape shows the range of tones that can be achieved using HB to 6B graphite pencils and charcoal and soft pastels. Working from light to dark gives the picture a sense of depth.

Use the harder grades of pencil for the lighter background and the softer grades for the dark foreground.

- Both pastels and charcoal need fixing.

- Take care not to rest your hand on the paper to avoid smudges.

- A smooth drawing paper was used for both drawings.

Build up the density gradually working up to the foreground silhouettes.

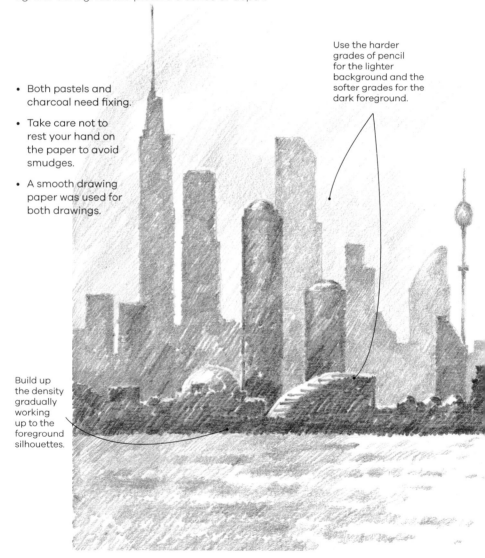

- To prevent charcoal dust from muddying the pastel colours, fix the charcoal drawing before adding the pastels.

When a combination of charcoal and soft pastel is used, the coverage is less uniform.

The texture of charcoal and soft pastel are similar and they blend together well.

Use charcoal over pastel to tone down bright colours.

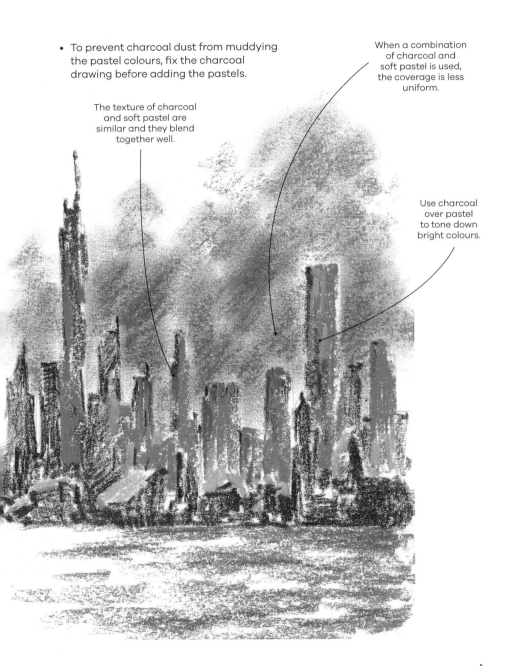

63 GRAPHITE STICKS, COLOURED AND WATER-SOLUBLE PENCILS

This owl was drawn using soft 4B and 8B graphite sticks on a smooth drawing paper.

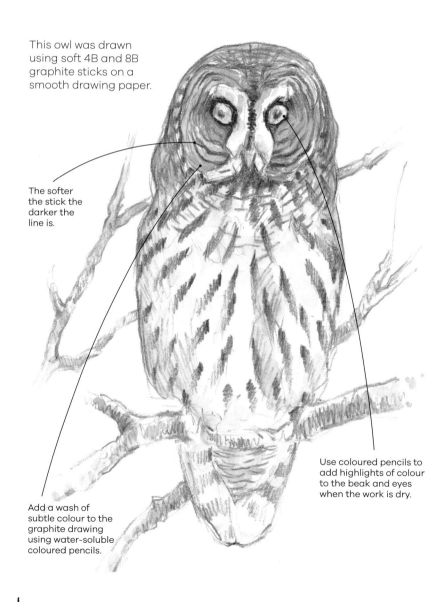

The softer the stick the darker the line is.

Add a wash of subtle colour to the graphite drawing using water-soluble coloured pencils.

Use coloured pencils to add highlights of colour to the beak and eyes when the work is dry.

GRAPHITE STICKS, CONTÉ AND SOFT PASTELS 64

Graphite sticks are the ideal choice for quick sketches to capture a pose.

Soft 4B and 8B sticks were used on a smooth drawing paper.

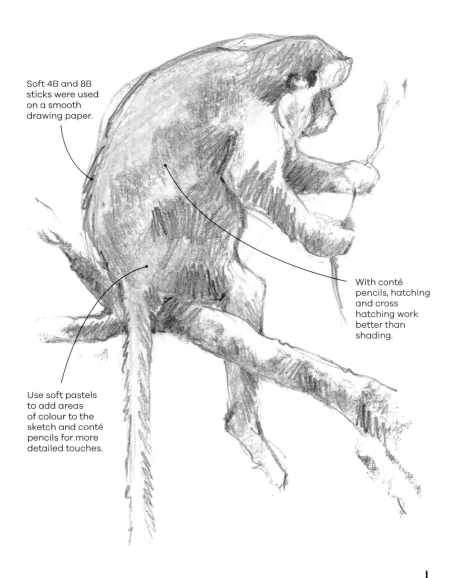

With conté pencils, hatching and cross hatching work better than shading.

Use soft pastels to add areas of colour to the sketch and conté pencils for more detailed touches.

GRAPHITE STICKS
65 AND HARD PASTELS

These sunflowers were drawn using hard pastels on a sand-based pastel paper. An 8B graphite stick adds depth to the shadows in the centre of the flowers.

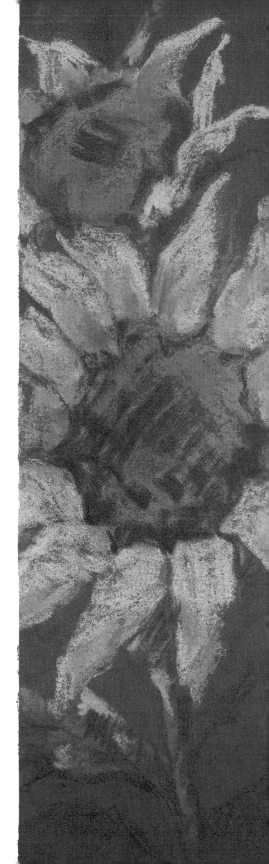

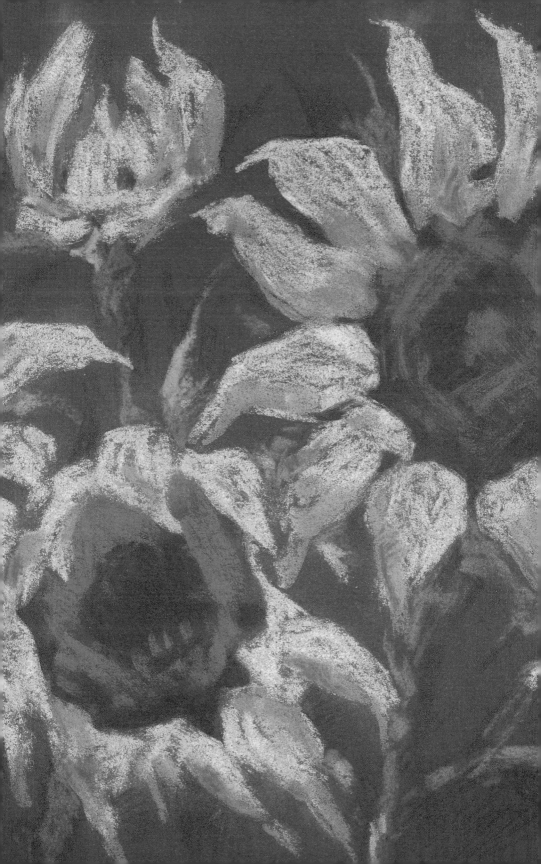

GRAPHITE POWDER, 66 CONTÉ AND SOFT PASTELS

A variety of media was used to produce the image of the racing car. Graphite powder is ideal for large scale drawing, as well producing light and shadow on paper, while conté pencils and soft pastels produced the outline of the image as base to start.

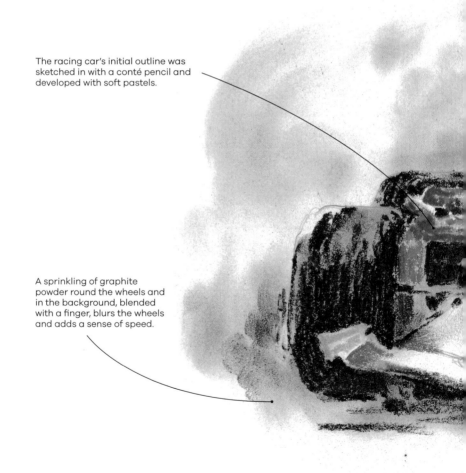

The racing car's initial outline was sketched in with a conté pencil and developed with soft pastels.

A sprinkling of graphite powder round the wheels and in the background, blended with a finger, blurs the wheels and adds a sense of speed.

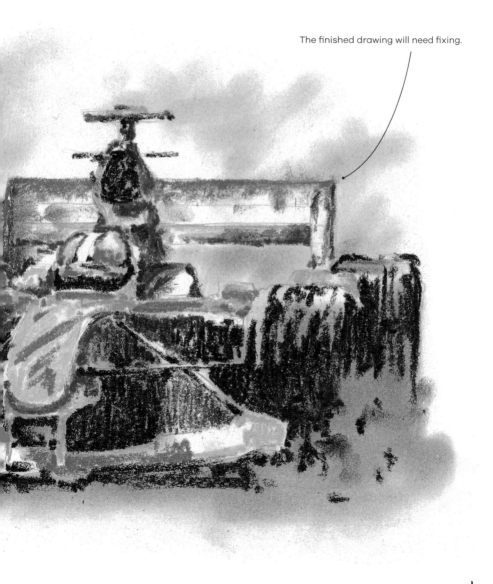

The finished drawing will need fixing.

COLOURED PENCILS, 67 SOFT PASTELS AND CHARCOAL

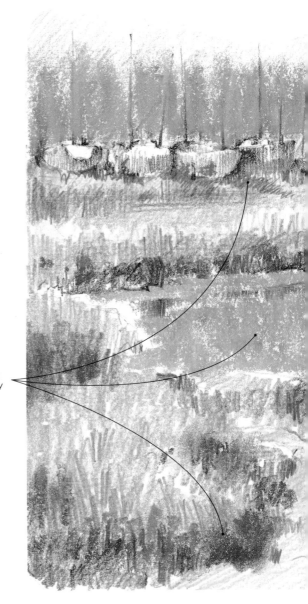

The contrasts in this drawing were created using three very different media.

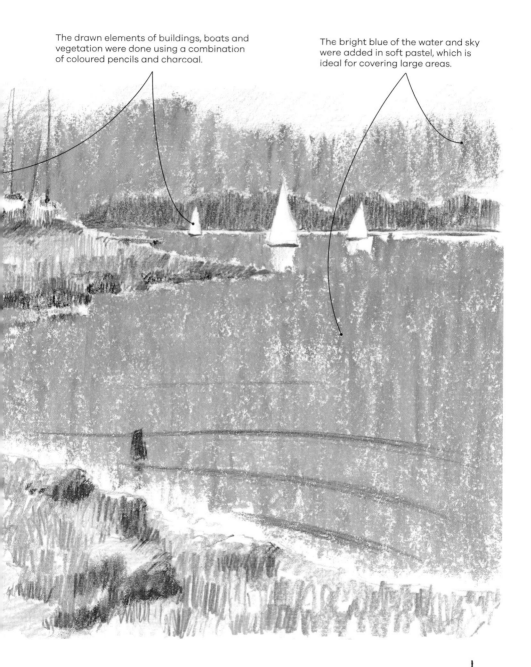

The drawn elements of buildings, boats and vegetation were done using a combination of coloured pencils and charcoal.

The bright blue of the water and sky were added in soft pastel, which is ideal for covering large areas.

COLOURED PENCILS, HARD
68 PASTELS AND BALLPOINT PEN

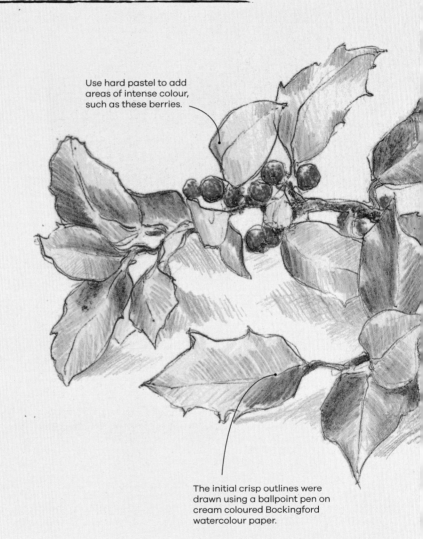

Use hard pastel to add areas of intense colour, such as these berries.

The initial crisp outlines were drawn using a ballpoint pen on cream coloured Bockingford watercolour paper.

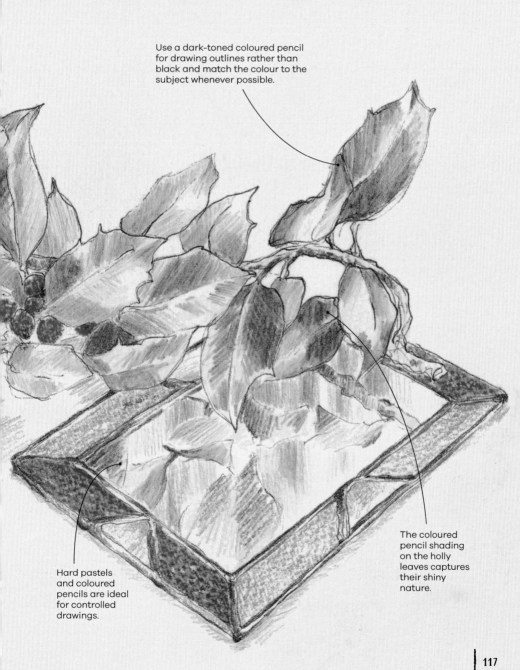

Use a dark-toned coloured pencil for drawing outlines rather than black and match the colour to the subject whenever possible.

The coloured pencil shading on the holly leaves captures their shiny nature.

Hard pastels and coloured pencils are ideal for controlled drawings.

WATERCOLOUR PENCILS, SOFT
69 PASTELS AND CHARCOAL PENCILS

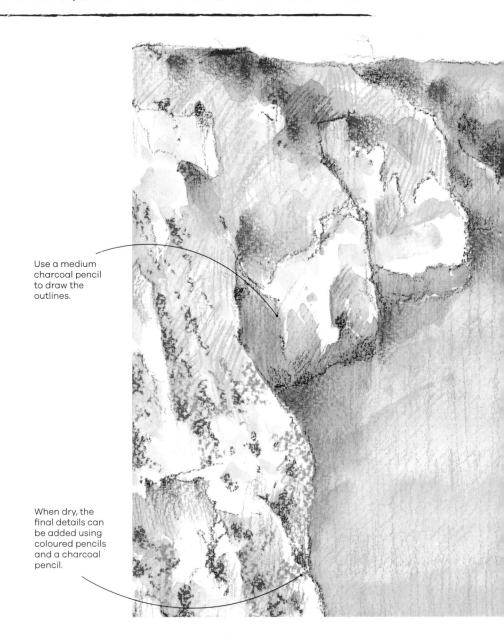

Use a medium charcoal pencil to draw the outlines.

When dry, the final details can be added using coloured pencils and a charcoal pencil.

To achieve a painterly effect, blend areas shaded with water-soluble pencils and soft pastels with a soft brush dipped in water.

Watercolour pencils and soft pastels can be blended using water and a soft brush. The NOT watercolour paper has a textured surface, which is ideal for this technique.

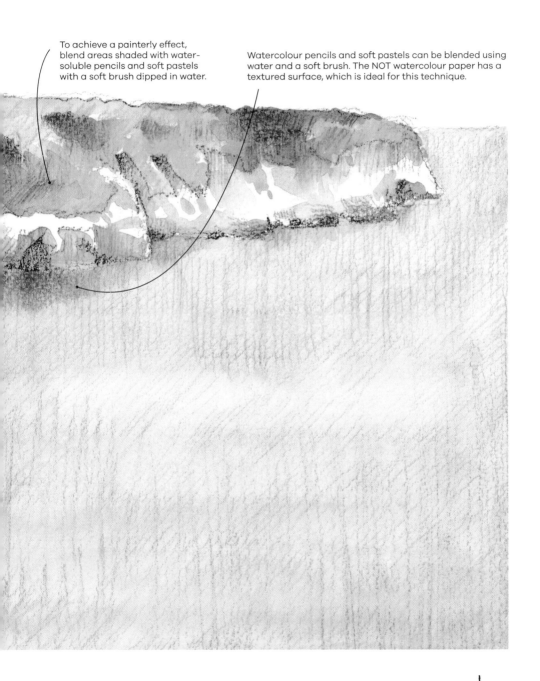

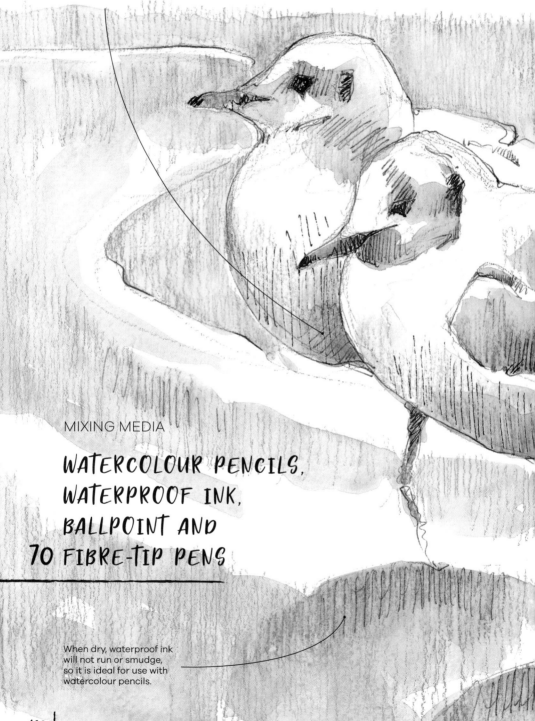

The outlines were drawn in waterproof ink, then shaded colours were added and softened with a brush dipped in water.

MIXING MEDIA

WATERCOLOUR PENCILS, WATERPROOF INK, BALLPOINT AND 70 FIBRE-TIP PENS

When dry, waterproof ink will not run or smudge, so it is ideal for use with watercolour pencils.

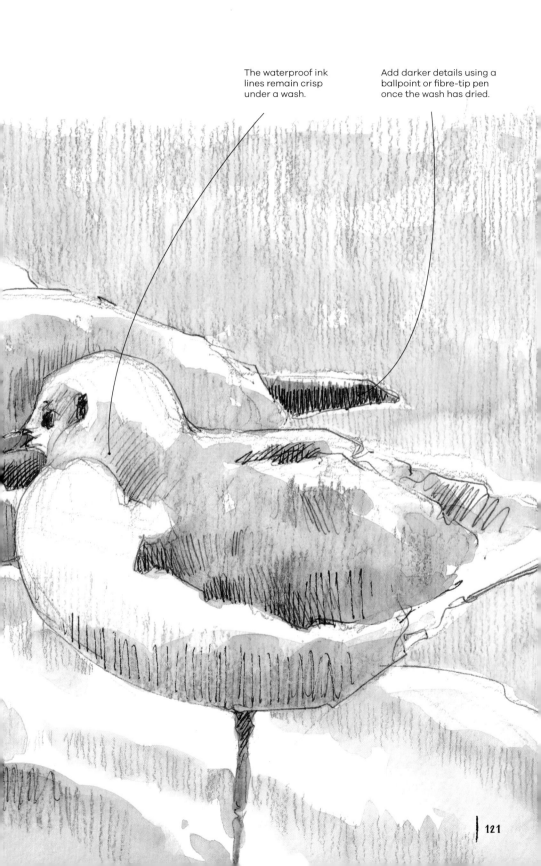

The waterproof ink lines remain crisp under a wash.

Add darker details using a ballpoint or fibre-tip pen once the wash has dried.

CHARCOAL STICKS AND PENCILS, 71 GRAPHITE STICKS AND COLOURED PENCILS

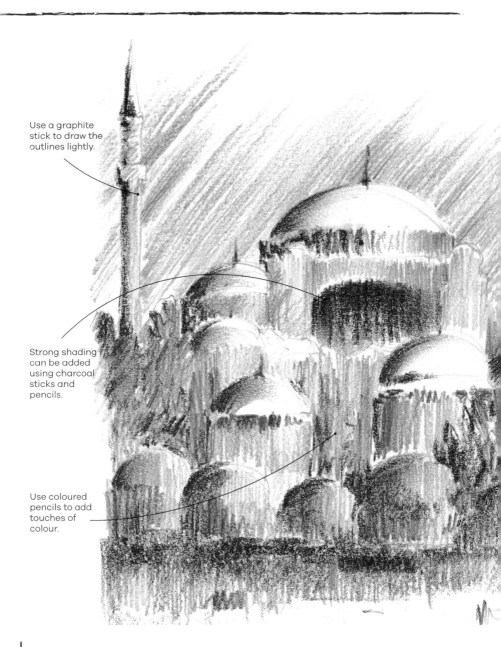

Use a graphite stick to draw the outlines lightly.

Strong shading can be added using charcoal sticks and pencils.

Use coloured pencils to add touches of colour.

CHARCOAL STICKS AND PENCILS, CONTÉ AND SOFT PASTELS 72

Soft pastel and charcoal will need fixing.

Blend the soft pastel using a finger.

The charcoal stick used to draw the outlines gives bold vigorous lines.

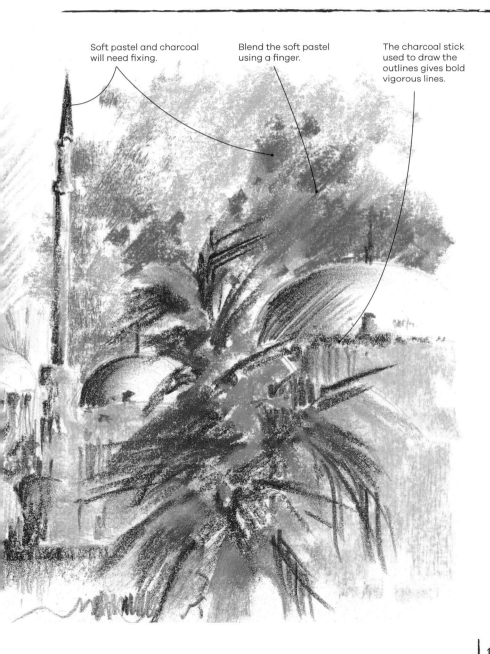

73 CHARCOAL STICKS AND PENCILS, WATERPROOF INK AND BALLPOINT PEN

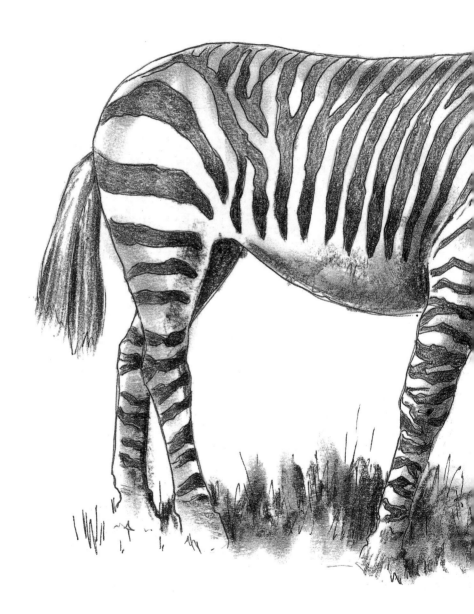

The outline sketch was drawn with a fine ballpoint pen, then worked up using charcoal sticks and charcoal pencils.

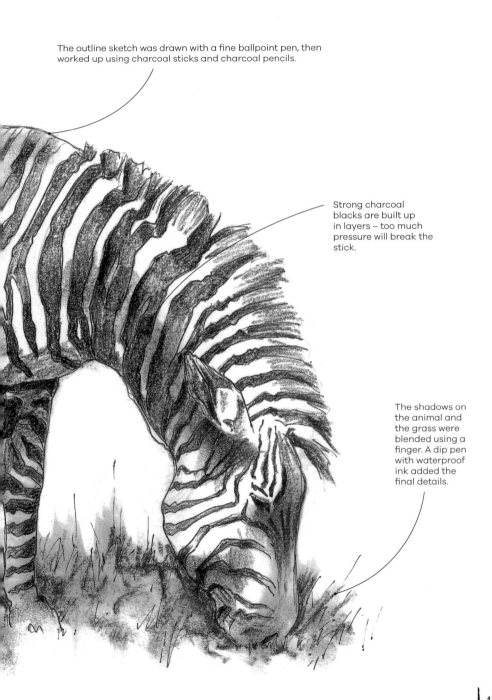

Strong charcoal blacks are built up in layers – too much pressure will break the stick.

The shadows on the animal and the grass were blended using a finger. A dip pen with waterproof ink added the final details.

CONTÉ, GRAPHITE AND
74 COLOURED PENCILS

- The delicate detailed drawing of this exotic scene was sketched in graphite pencil on smooth drawing paper.

- As well as earth shades, conté sticks and pencils are available in a range of colours that combine well with coloured pencils.

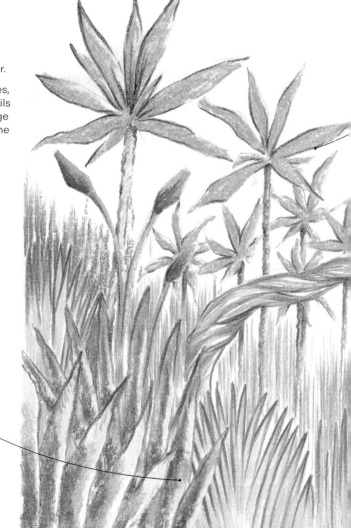

A combination of coloured pencils and conté sticks blended together produces vibrantly coloured foliage.

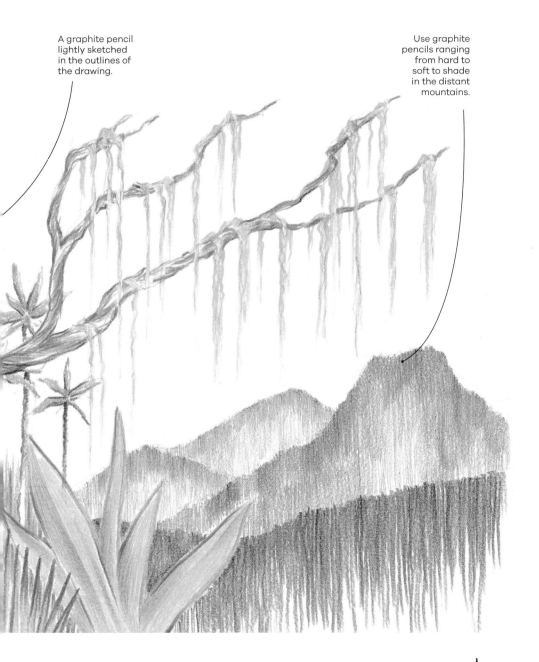

A graphite pencil lightly sketched in the outlines of the drawing.

Use graphite pencils ranging from hard to soft to shade in the distant mountains.

CONTÉ, WATERPROOF INK
75 AND BALLPOINT PEN

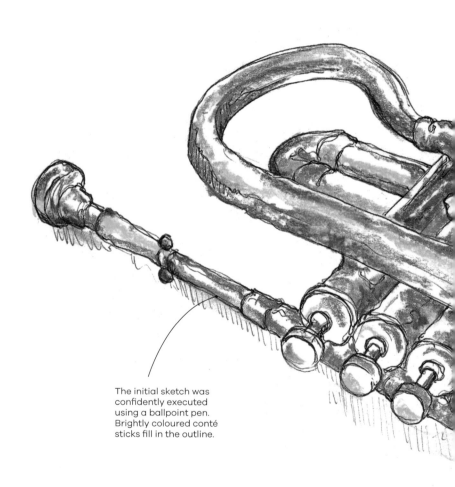

The initial sketch was
confidently executed
using a ballpoint pen.
Brightly coloured conté
sticks fill in the outline.

The corners of a conté stick produce fine, controlled lines. The sticks can also be sharpened with a craft knife.

Use the squared ends of the conté stick to produce wide sweeping strokes of colour.

The shaded areas were hatched in using a dip pen and waterproof ink.

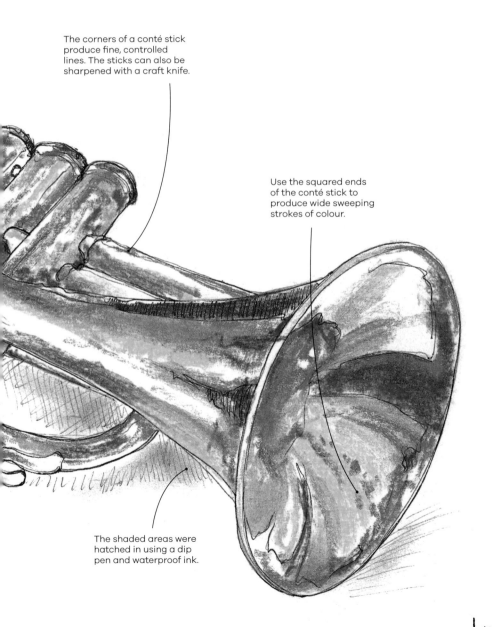

PASTEL PENCILS, CONTÉ
76 AND HARD PASTELS

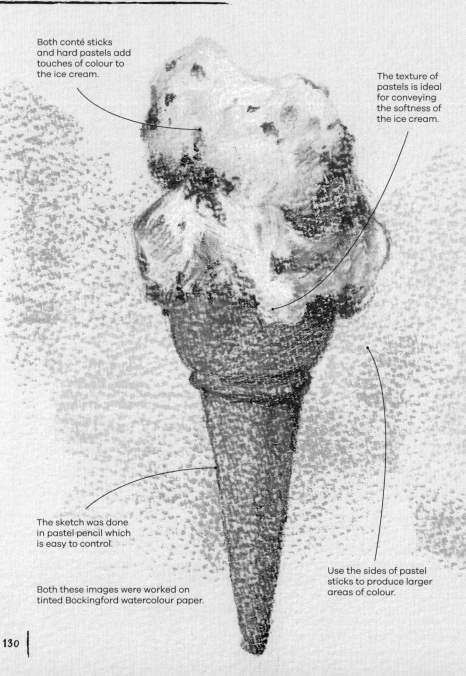

Both conté sticks and hard pastels add touches of colour to the ice cream.

The texture of pastels is ideal for conveying the softness of the ice cream.

The sketch was done in pastel pencil which is easy to control.

Both these images were worked on tinted Bockingford watercolour paper.

Use the sides of pastel sticks to produce larger areas of colour.

PASTEL PENCILS, WATERPROOF INK AND BALLPOINT PEN 77

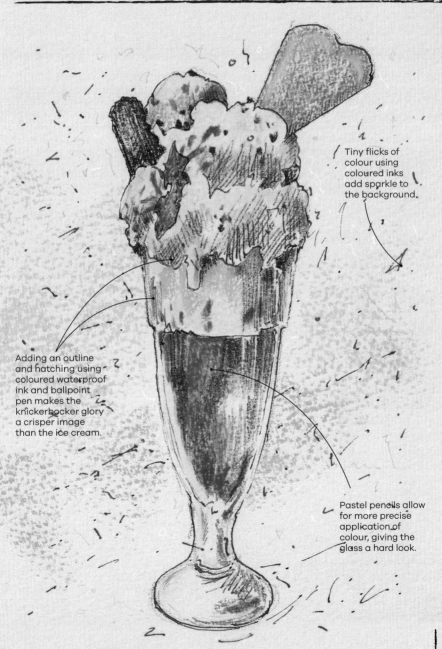

Tiny flicks of colour using coloured inks add sparkle to the background.

Adding an outline and hatching using coloured waterproof ink and ballpoint pen makes the knickerbocker glory a crisper image than the ice cream.

Pastel pencils allow for more precise application of colour, giving the glass a hard look.

SOFT PASTELS, GRAPHITE 78 AND WATERCOLOUR PENCILS

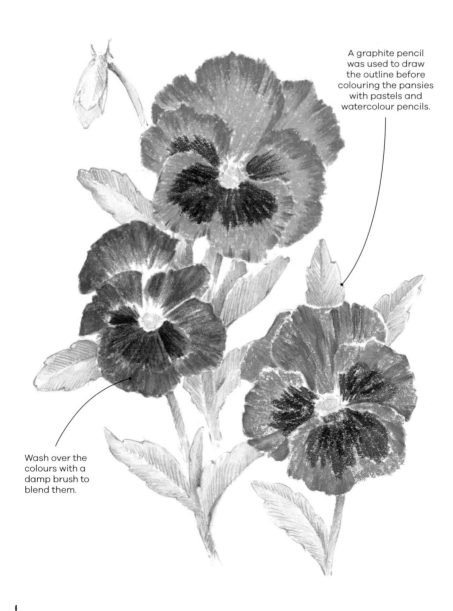

A graphite pencil was used to draw the outline before colouring the pansies with pastels and watercolour pencils.

Wash over the colours with a damp brush to blend them.

SOFT PASTELS, CHARCOAL AND HARD PASTELS 79

Charcoal can be added to a pastel drawing, working on top of the colours. Both charcoal and pastels need fixing when the drawing is complete.

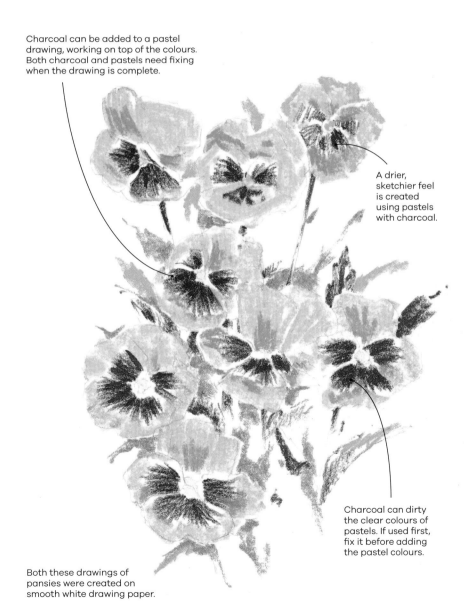

A drier, sketchier feel is created using pastels with charcoal.

Charcoal can dirty the clear colours of pastels. If used first, fix it before adding the pastel colours.

Both these drawings of pansies were created on smooth white drawing paper.

SOFT PASTELS, BALLPOINT 80 AND FIBRE-TIP PENS

The outline was drawn with a ballpoint and fine fibre-tip pens.

Blend soft pastels with a finger for the overall colour before adding and blending the darker colours, used for the contours and shading.

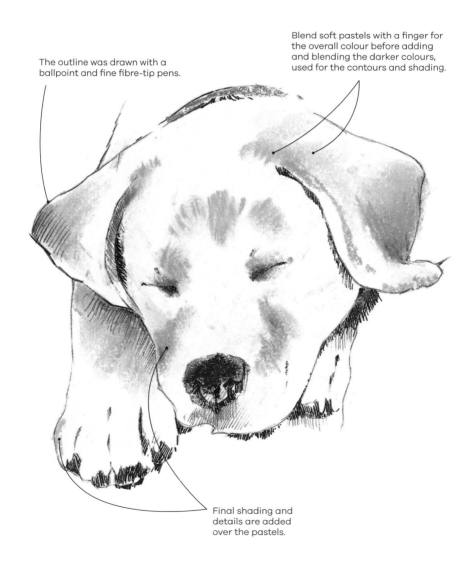

Final shading and details are added over the pastels.

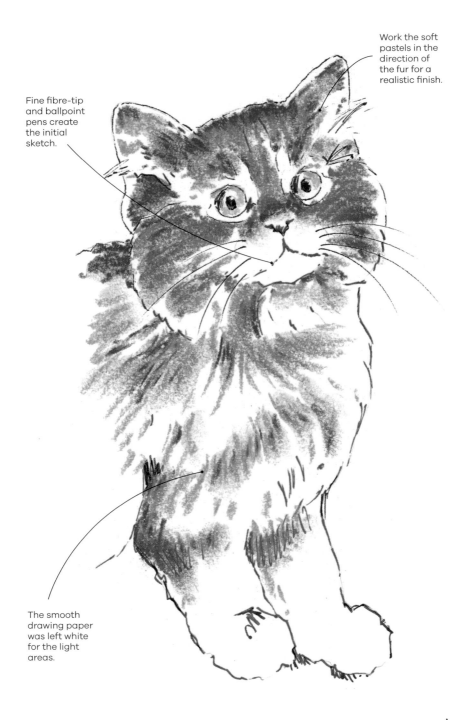

Work the soft pastels in the direction of the fur for a realistic finish.

Fine fibre-tip and ballpoint pens create the initial sketch.

The smooth drawing paper was left white for the light areas.

HARD PASTELS, GRAPHITE
81 AND COLOURED PENCILS

A combination of hard pastels and coloured pencils were used to create the sky effects below. The foreground was shaded using a soft graphite pencil. The result is a soft dreamy evening sky.

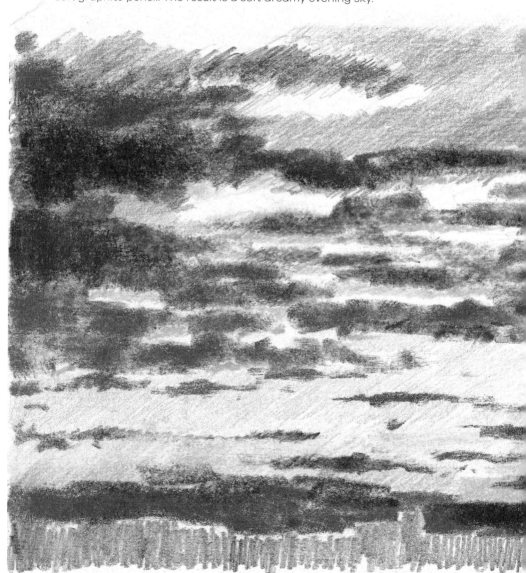

HARD AND SOFT PASTELS AND CHARCOAL 82

When soft pastels are used instead of coloured pencils, the colours are strengthened. Adding charcoal deepens the colour of the clouds and the foreground is more of a silhouette. This sunset is much more dramatic.

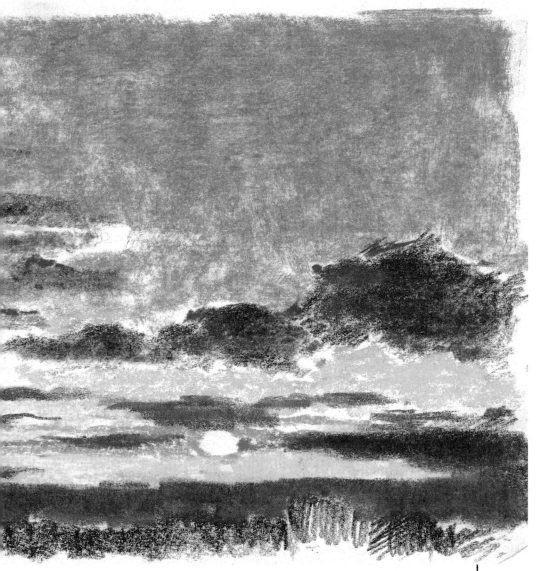

83 HARD PASTELS, ACRYLIC AND WATERPROOF INKS

The linear quality of hard pastels works well with inks, ballpoint pens and felt-tip pens.

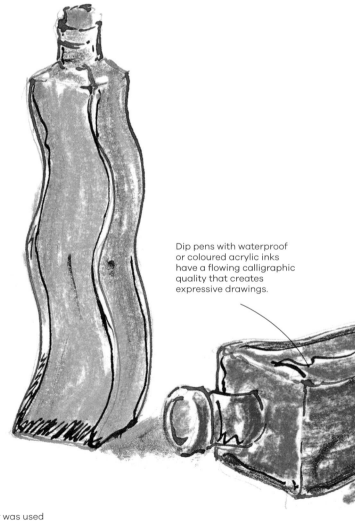

Dip pens with waterproof or coloured acrylic inks have a flowing calligraphic quality that creates expressive drawings.

A smooth drawing paper was used as a support for these sketches.

HARD PASTELS, BALLPOINT AND FELT-TIP PENS

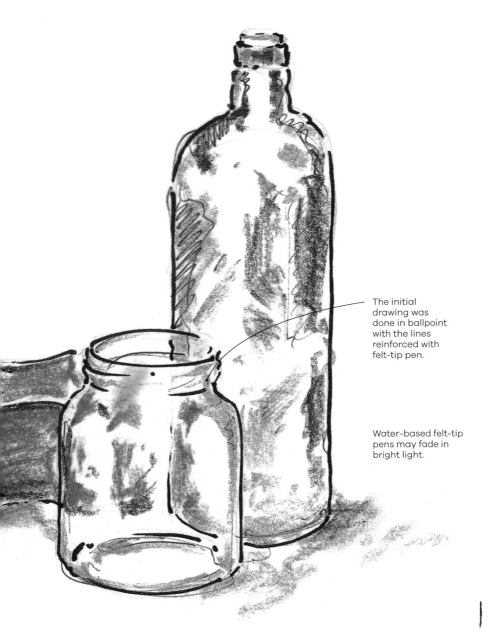

The initial drawing was done in ballpoint with the lines reinforced with felt-tip pen.

Water-based felt-tip pens may fade in bright light.

WAX CRAYONS, GRAPHITE
85 STICKS AND CHARCOAL

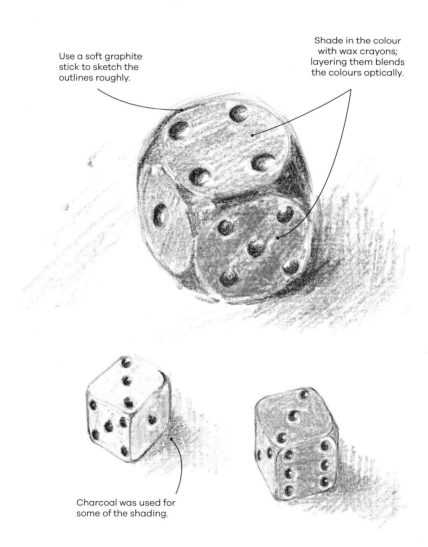

Use a soft graphite stick to sketch the outlines roughly.

Shade in the colour with wax crayons; layering them blends the colours optically.

Charcoal was used for some of the shading.

WAX CRAYONS, WATERPROOF INK AND BALLPOINT PEN

86

A combination of dip pens with waterproof ink and ballpoint pen produced the crisp outline drawing.

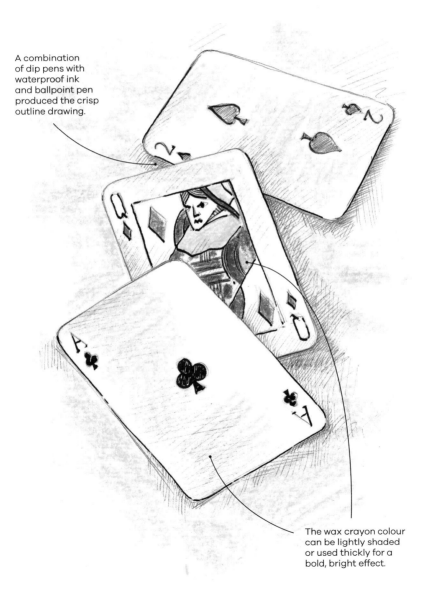

The wax crayon colour can be lightly shaded or used thickly for a bold, bright effect.

87 PEN AND WASH

Traditionally, artists use black or sepia waterproof ink to create a detailed drawing to which soft washes of colour are added when the ink is completely dry. A looser, less structured effect is created by adding a drawn pen and ink outline to areas of soft colour washes after the paint has dried.

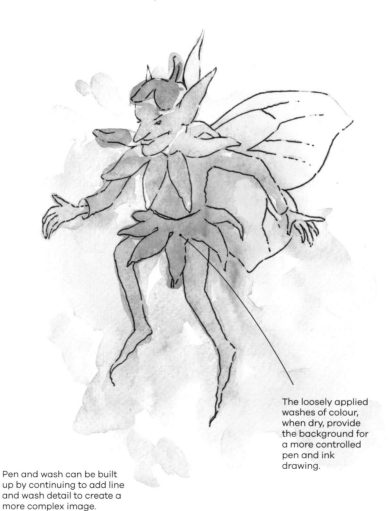

The loosely applied washes of colour, when dry, provide the background for a more controlled pen and ink drawing.

Pen and wash can be built up by continuing to add line and wash detail to create a more complex image.

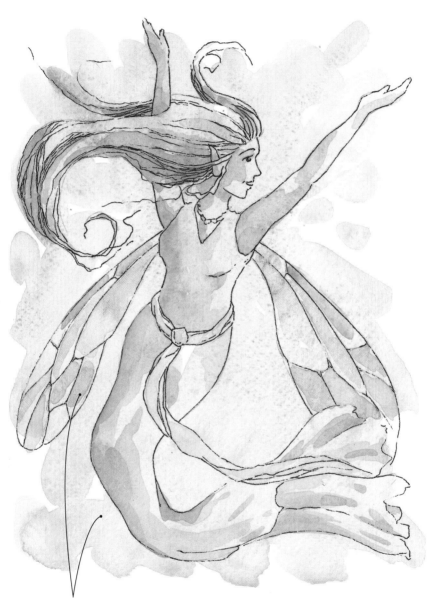

Once the ink drawing is completely dry the washes are applied. Some keep within the drawn outlines, others are loose and free.

WATERPROOF INK, WATER-SOLUBLE
88 COLOURED PENCILS AND CHARCOAL

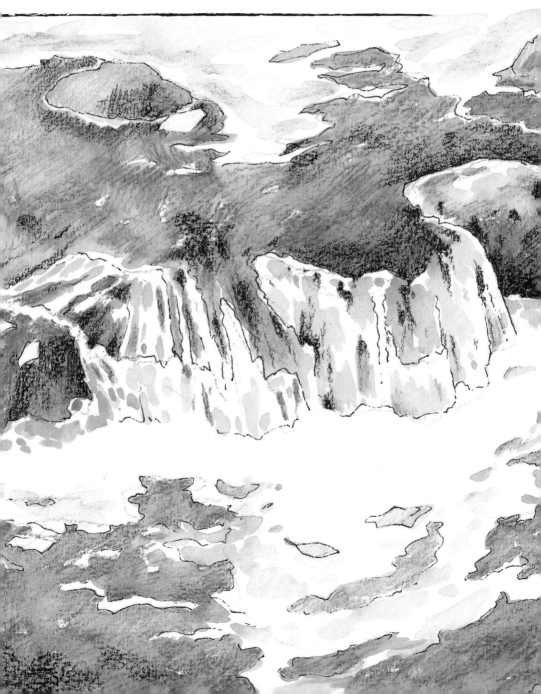

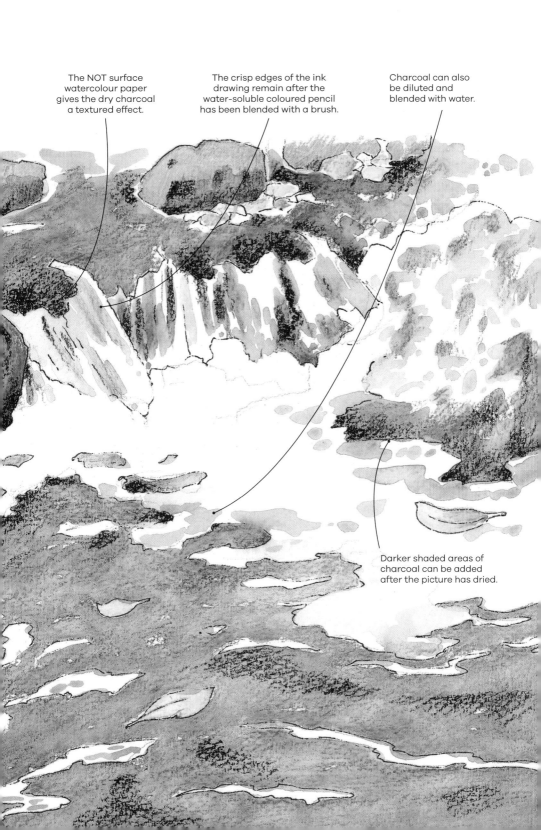

The NOT surface watercolour paper gives the dry charcoal a textured effect.

The crisp edges of the ink drawing remain after the water-soluble coloured pencil has been blended with a brush.

Charcoal can also be diluted and blended with water.

Darker shaded areas of charcoal can be added after the picture has dried.

WATER-SOLUBLE INK 89 AND GRAPHITE PENCILS

Drawings can be softened using a damp brush. Once it has dried, the outlines can be touched in to replace any crispness that has been lost.

Water-soluble ink dries to a matt finish. Waterproof shellac-based inks are more shiny.

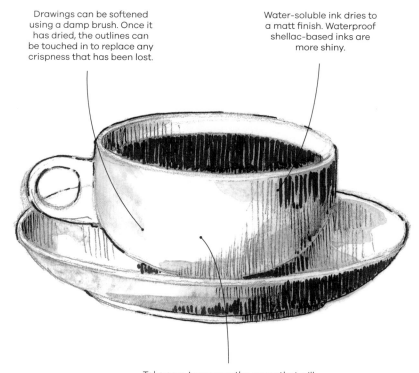

Take care to reserve the areas that will remain white when adding the wash.

WATER-SOLUBLE INK, FELT-TIP AND BALLPOINT PEN AND GRAPHITE PENCIL 90

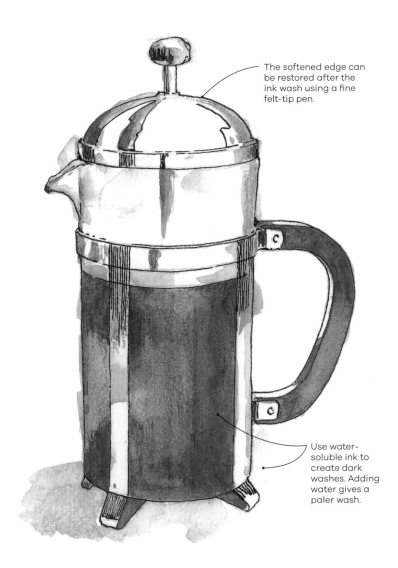

The softened edge can be restored after the ink wash using a fine felt-tip pen.

Use water-soluble ink to create dark washes. Adding water gives a paler wash.

ACRYLIC INK, GRAPHITE
91 PENCIL OR BALLPOINT PEN

Contrast the soft shaded areas of graphite pencil on the left with the harder hatched areas using a ballpoint pen on the right.

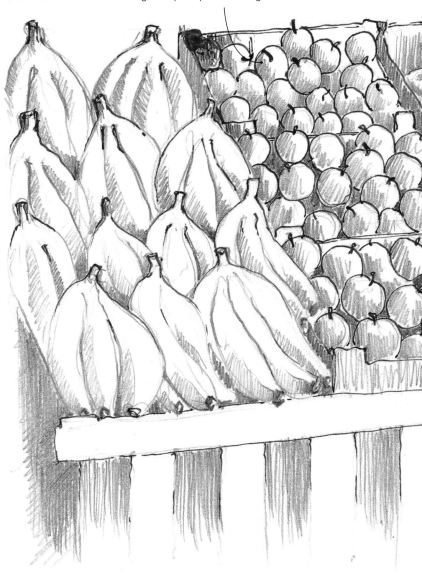

Colour is introduced using acrylic inks.

Acrylic inks can be mixed to create a range of colours. They are waterproof when dry.

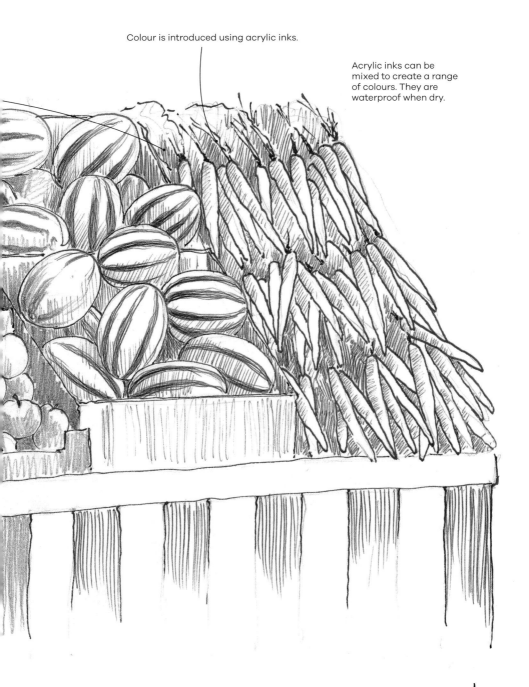

BALLPOINT PEN AND
92 GRAPHITE PENCIL

A pencil and ballpoint pen are always useful to
have ready when out sketching.

This monochrome graphite
pencil sketch has been crisped
up with touches of ballpoint pen.

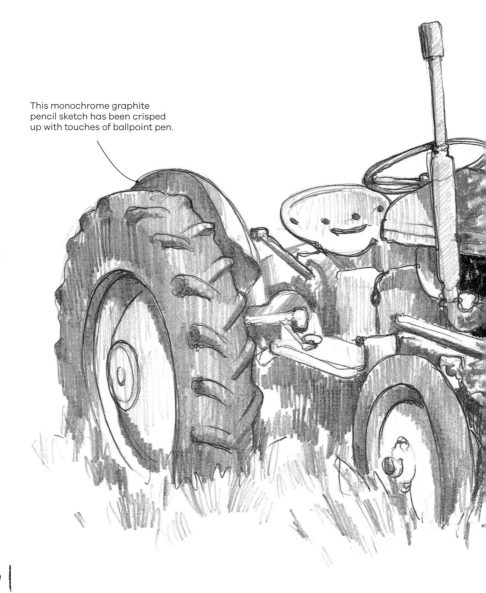

BALLPOINT PEN AND
SOFT PASTELS

93

A stronger outline sketch using a ballpoint pen was the basis for a soft pastel study of the tractor.

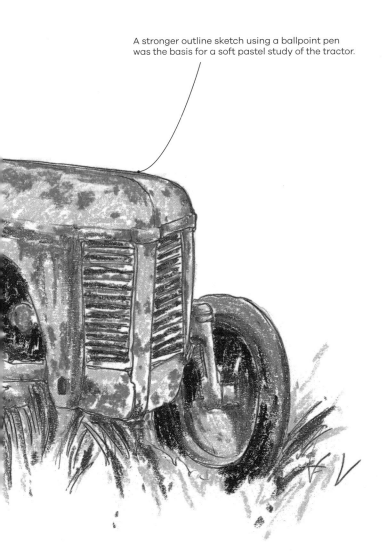

FIBRE-TIP AND MARKER
94 PENS AND CHARCOAL

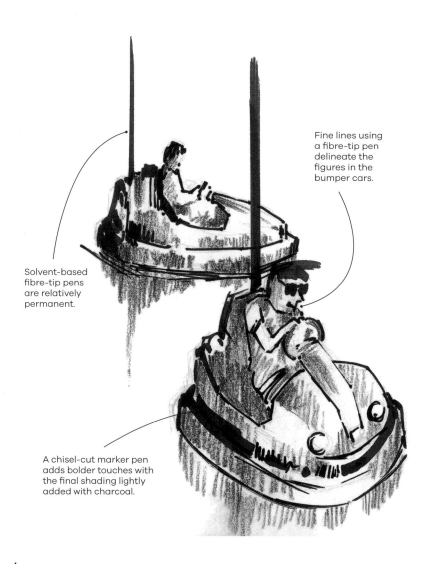

Fine lines using a fibre-tip pen delineate the figures in the bumper cars.

Solvent-based fibre-tip pens are relatively permanent.

A chisel-cut marker pen adds bolder touches with the final shading lightly added with charcoal.

FIBRE-TIP PENS AND WATERPROOF INK 95

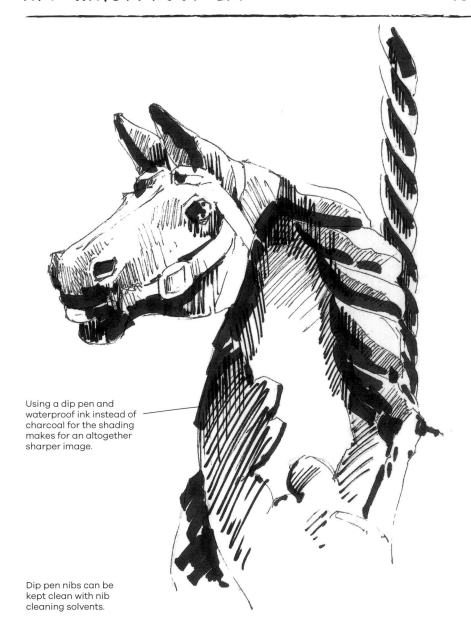

Using a dip pen and waterproof ink instead of charcoal for the shading makes for an altogether sharper image.

Dip pen nibs can be kept clean with nib cleaning solvents.

BRUSH PENS AND
96 COLOURED PENCILS

- Before using brush pens, practise doodling on scrap paper to learn how to control the marks they make and the ink flow.

- Flowing lines, broad strokes and fine detail are all possible with brush pens.

Use a single colour brush pen with its flowing lines to make the outline sketch.

Coloured pencils shade in the colour.

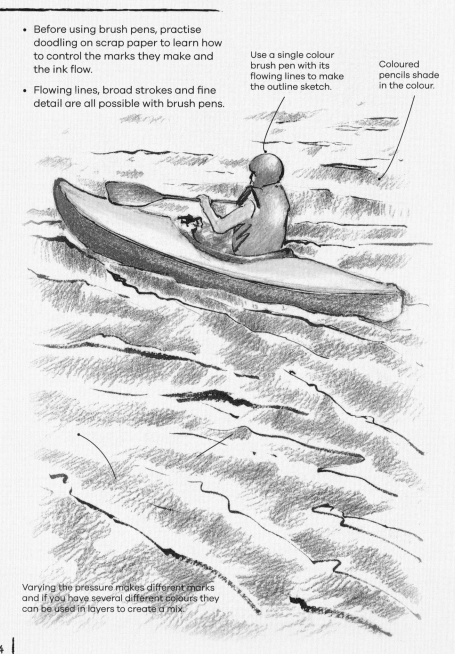

Varying the pressure makes different marks and if you have several different colours they can be used in layers to create a mix.

BALLPOINT AND BRUSH PENS
AND WATERPROOF INK 97

Ballpoint pen lines are uniform in width. Build up density by working them close together or by cross hatching.

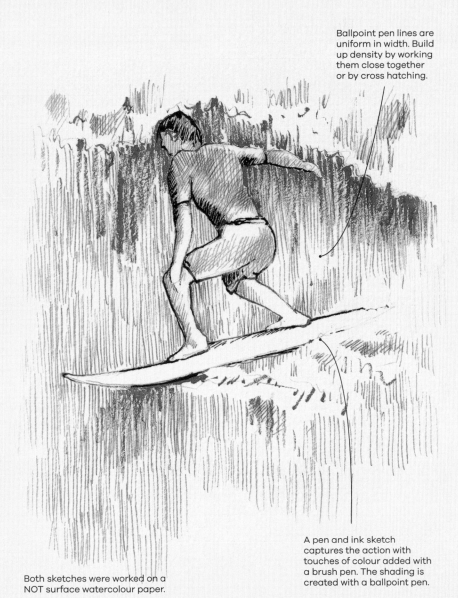

A pen and ink sketch captures the action with touches of colour added with a brush pen. The shading is created with a ballpoint pen.

Both sketches were worked on a NOT surface watercolour paper.

98 OIL PASTELS AND GRAPHITE STICKS

To prevent the underdrawing showing through or smudging oil pastels, use an HB or harder graphite lead. If a softer lead is used, erase it leaving just a trace of the lines, particularly if light coloured pastels are to be used.

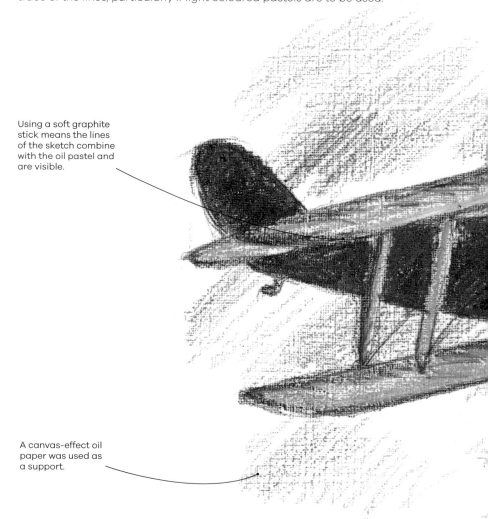

Using a soft graphite stick means the lines of the sketch combine with the oil pastel and are visible.

A canvas-effect oil paper was used as a support.

OIL PASTELS AND FELT-TIP PENS

A felt-tip pen gives a harder edge to the drawing. It does not combine with the oil pastel, nor does it smudge or dilute.

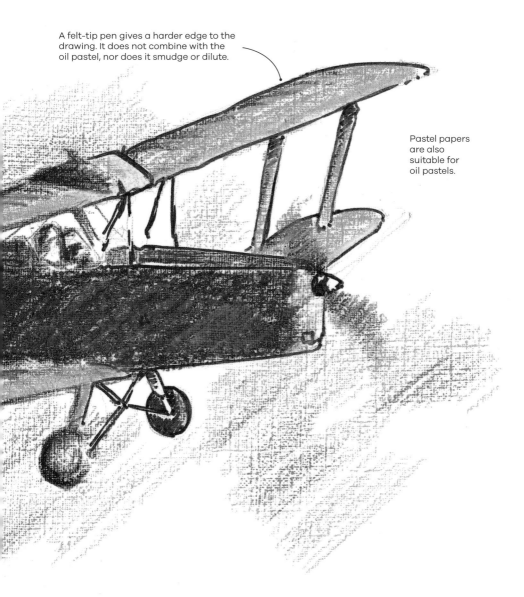

Pastel papers are also suitable for oil pastels.

OIL PAINT STICKS
100 AND GRAPHITE STICKS

These luscious sticks are extremely soft and can be used for a quick sketch or to add colour to a drawing as a painting medium. They can be used on any support suitable for oil paints.

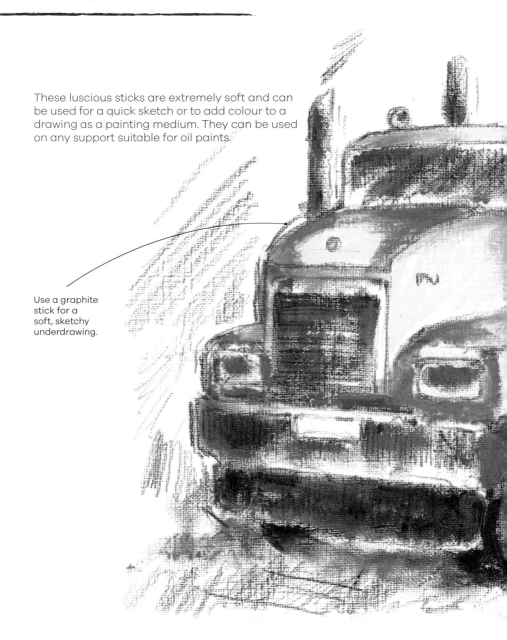

Use a graphite stick for a soft, sketchy underdrawing.

OIL PAINT STICKS AND FELT-TIP PENS 101

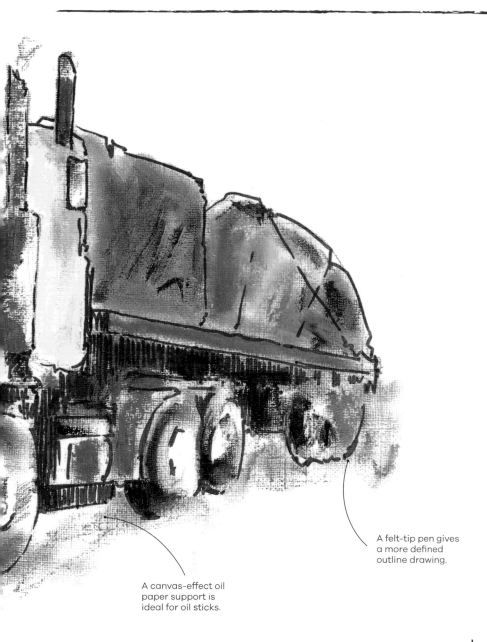

A felt-tip pen gives a more defined outline drawing.

A canvas-effect oil paper support is ideal for oil sticks.

INDEX

A DAVID AND CHARLES BOOK
© David and Charles, Ltd 2008, 2021

David and Charles is an imprint of David and Charles, Ltd, Suite A, Tourism House, Pynes Hill, Exeter, EX2 5WS

Text and Designs © David Webb 2008, 2021
Layout and Photography © David and Charles, Ltd 2008, 2021

Originally published as *Drawing Index* in 2008
This book first published in the UK and USA in 2021

David Webb has asserted his right to be identified as author of this work in accordance with the Copyright, Designs and Patents Act, 1988.

The author and publisher have made every effort to ensure that all the instructions in the book are accurate and safe, and therefore cannot accept liability for any resulting injury, damage or loss to persons or property, however it may arise.

Names of manufacturers and product ranges are provided for the information of readers, with no intention to infringe copyright or trademarks.

A catalogue record for this book is available from the British Library.

ISBN-13: 9781446308677 paperback
ISBN-13: 9781446380703 EPUB

This book has been printed on paper from approved suppliers and made from pulp from sustainable sources.

Printed in China by Asia Pacific for:
David and Charles, Ltd
Suite A, Tourism House, Pynes Hill, Exeter, EX2 5WS

10 9 8 7 6 5 4 3 2 1

Publishing Director: Ame Verso
Senior Commissioning Editor: Freya Dangerfield
Managing Editor: Jeni Chown
Editor: Verity Muir
Designer: Sarah Rowntree
Production Controller: Beverley Richardson

David and Charles publishes high-quality books on a wide range of subjects. For more information visit www.davidandcharles.com.

Layout of the digital edition of this book may vary depending on reader hardware and display settings.